PAINTING, PHOTOGRAPHY, FILM

LASZLO MOHOLY-NAGY

PAINTING
PHOTOGRAPHY
FILM

WITH A NOTE BY HANS M WINGLER
AND A POSTSCRIPT BY OTTO STELZER
TRANSLATED BY JANET SELIGMAN

LUND HUMPHRIES, LONDON

First English edition 1969
Published by Lund Humphries, 12 Bedford Square, London WC1
Made and printed in Great Britain by Lund Humphries, London and
Bradford

Publishers' note

This is a translation of *Malerei, Fotografie, Film* which originally
appeared as Volume 8 in the *Bauhausbücher* series in 1925 (second
edition 1927). The German edition was reissued in 1967 in
facsimile in the series *Neue Bauhausbücher* by Florian Kupferberg
Verlag, Mainz. In an effort to convey something of the true flavour
of the original volume, an attempt has been made in this English
language edition to adhere as closely as possible to the original
typography and make up of the (second) German edition

CONTENTS

INTRODUCTION

I.

In this book I seek to identify the ambiguities of present-day optical crea-
tion. The means afforded by photography play an important part therein,
though it is one which most people today still fail to recognise: extending
the limits of the depiction of nature and the use of light as a creative
agent: chiaroscuro in place of pigment.

The camera has offered us amazing possibilities, which we are only just
beginning to exploit. The visual image has been expanded and even the
modern lens is no longer tied to the narrow limits of our eye; no manual
means of representation (pencil, brush, etc.) is capable of arresting frag-
ments of the world seen like this; it is equally impossible for manual means
of creation to fix the quintessence of a movement; nor should we regard
the ability of the lens to distort – the view from below, from above, the
oblique view – as in any sense merely negative, for it provides an impartial
approach, such as our eyes, tied as they are to the laws of association, do
not give; and from another point of view: the delicacy of the grey effects
produces a sublimated value, the differentiation of which can transcend
its own sphere of influence and even benefit colour composition. But when
we have enumerated these uses, we are still far from having exhausted the
possibilities in the field. We are only beginning to exploit them; for –
although photography is already over a hundred years old – it is only in
recent years that the course of development has allowed us to see beyond
the specific instance and recognise the creative consequences. Our vision
has only lately developed sufficiently to grasp these connections.

II.

The first essential is to clarify the relationship of **photography** to the **painting** of today and to show that the development of technical means has materially contributed to the genesis of new forms in **optical** creation and has split the hitherto indivisible field of optical expression. Until photography was invented, painting combined within itself the missions of representation and expression in colour. Now since the division, one field embraces

pure **colour** composition, the other

representational composition.

COLOUR COMPOSITION: The pure inter-relationships of colours and light-values, similar to what we know in music as composition in acoustical relationships; that is, the composition of universal systems, independent of climate, race, temperament, education, rooted in biological laws;

REPRESENTATIONAL COMPOSITION: Relationships of elements imitatively derived from without, objective elements with associative contents, as, in acoustical composition, speech exists side by side with music; this is the composition of systems dependent upon climate, race, temperament, education, rooted in association and experience. Creative elements which are rooted in biological laws can also be mobilised as constructional and compositional auxiliaries●).

This division is not undoing all that the human spirit has achieved hitherto; on the contrary: the pure forms of expression are being crystallised and are becoming more telling in their effect for being autonomous.

●) *Representation* is not identical with nature or a slice of nature. E.g., when we seek to fix a fantasy or a dream the results are equally representational.

In the hands of an original artist *representation* becomes *creation*, otherwise it remains mere *reportage*. The introduction and spread of colour photography, a development which has had a very short history, in no way alters this situation.

III.

I summarise the current consequences of this situation:

1. In the exact mechanical procedures of photography and the film we possess an expressional means for **representation** which works incomparably better than did the manual procedures of the representational painting we have known hitherto.

From now on painting can concern itself with **pure colour composition.**

2. Pure colour composition shows that the 'theme' of colour composition (painting) is **colour itself,** that with colour, without objective references, a pure and primary, a composed expression, can be achieved.

3. The newly invented optical and technical instruments offer the optical creator valuable suggestions; among other things they give us light painting side by side with painting in pigment, **kinetic** painting side by side with **static.** (Moving light displays side by side with easel-painting, instead of frescos – films in all dimensions; outside the film theatre, too, of course.)

●

I do not wish with these remarks to pass value judgments on the various modes of painterly creation, but simply to classify those optical creations which exist or could exist today in the sense of the application of means. The quality of a work need not be dependent absolutely on a 'modern' or an 'old' theory of composition. It is dependent on the degree of inventive intensity which finds its technically appropriate form. All the same, it seems to me indispensable that we, the creators of our **own time,** should go to work with **up-to-date** means.

FROM
PAINTING WITH PIGMENT
TO
LIGHT DISPLAYS
PROJECTED
WITH A REFLECTOR

PROBLEMS
OF TERMINOLOGY
IN
OPTICAL
COMPOSITION

In the interests of better understanding we need to grapple with the whole contemporary problem of optical creation: with

objective and

non-objective painting,

easel painting and

colour composition in an architectonic context,

which is linked with the problem of the

'Gesamtkunstwerk'; with

static and

kinetic optical composition, with the material

pigment and the material

light.

ON THE OBJECTIVE AND THE NON-OBJECTIVE

The biological functions of colour, its psycho-physical effects, have as yet scarcely been examined. One thing, however, is certain: it is an elementary biological necessity for human beings to absorb colour, to extract colour. We must assume that there are conditions of colour relationships and tensions, light values, forms, positions, directions which are common to all men and determined by our physiological mechanisms. E.g., complementary colours, the ways in which colours can be arranged centrically and eccentrically, centrifugally and centripetally, values of brightness and darkness – black and white content – the warmth and coldness of colours, their advancing and receding movements, the lightness and weight of colours.

Biologically conditioned expression of these relationships or tensions – be it conscious or unconscious – results in the concept of **absolute painting.** In fact these conditions have at all times been the true content of *colour composition.* I.e. the paintings of every age must have been formed from these primal states of tension grounded in man. The observable variations between the painting of different periods can be explained *only as periodic* formal variations of the same phenomenon. In practical terms this means that a painting – quite apart from its so-called 'theme' – must make its effect simply through the harmony of its colours and its chiaroscuro. **E.g. a picture could be standing on its head and still provide a sufficient basis for an assessment of its worth as a painting.** Of course, neither its use of colour nor its representational intentions (that is, its objectivity only) fully accounts for the character of a painting of the *earlier* periods of art. Its character is revealed only in the inseparable conjunction of the two. It is difficult

today, if not impossible, to reconstruct the stages by which old paintings came into being. All the same, with the aid of the concept 'absolute painting', we can distinguish a number of the components; and especially the components which derive from *elementary states of tension* and from *form as determined by time*.

●

During the course of his cultural development man has unceasingly endeavoured to master problems and to use them to express himself (to communicate, to depict). The desire somehow to hold fast the natural phenomena of his environment and the imaginings of his mind has operated with special intensity. Without examining the biological or other reasons for the genesis of the picture (art-historical interpretations of the use of symbols, attainment of power through the act of mastery, etc.), we can say that man has with ever mounting joy conquered the image of reality transposed into colours and forms and the content of fantasy caught in a pictorial rendering. Even the elementary states of tension of the colours and light values which in primitive phases of culture ordinarily appeared and were organised in other ways (garments, domestic implements, etc.) are here imbued with intensity. In this way the primal imitative urges have been enormously heightened for they touch also upon the elementary biological basis.

Development in every field of creation has led man to concentrate upon establishing means exclusively appropriate to the work. Extreme mastery and extreme inventiveness have been displayed in bringing out what is essential and elementary, in discovering basic constellations and organising them. Thus painting too came to recognise its elementary means: colour and plane. This recognition has been aided by the invention of the *mechanical process of representation: photography*. People have discovered on the one hand the possibility of representing, in an objective, mechanical manner, the effortless crystallising out of a law stated in its own medium; on the other hand it has become clear that *colour composition carries its 'subject' within itself, in its colour*.

Natural objects, material subjects: these arbitrary bearers of *moments of colour* are not needed today for the unambiguous effect of colour com-

position. A continuous and progressive development of photography and the film will soon show that these techniques enable us to fulfil representational purposes incomparably more completely than painting as it has been known hitherto could ever do. Although no general understanding of the situation as yet exists, this intuitive comprehension, rooted as it is in the sensibility of the age, has, with other factors●) greatly aided the advance of 'non-objective', 'abstract' painting.

A 'non-objective' painter needs no special courage to embrace the art of creative presentation as provided today by photography and the film. Man's interest in getting to know the whole world has been enlarged by the feeling of being – at every moment – in every situation – involved in it. We cannot therefore express hostility towards representational art but must demand that in conformity with our interest in and feeling for the world at large, up-to-date consequences are drawn: that painterly methods of representation suggestive merely of past times and past ideologies shall disappear and their place be taken by **mechanical means of representation** and their as yet unpredictable **possibilities of extension.** In such a situation the discussion about objective and non-objective *painting* will cease to be important; the whole problem will have to be comprised in **absolute** and (not 'or' but **and**) **representational** optical *creation*.

●) 'With other factors' in this context signifies a special field intimately embedded in the whole temporal and spiritual condition of the world or, in less pretentious terms: the cultural situation of the moment. One such factor, for example – as it will be of some importance to recognise – is that the interplay of various facts has caused our age to shift almost imperceptibly towards colourlessness and grey: the grey of the big city, of the black and white newspapers, of the photographic and film services; the colour-eliminating tempo of our life today. Perpetual hurry, fast movement, cause all colours to melt into grey. Organised grey-relationships, the living relationships of chiaroscuro, will, of course, emerge later on as a new aspect of the biological-optical experience of colour. Intensive examination of photographic means will certainly contribute much to this. In view of these contingencies, we shall need to bring still greater readiness and care to sovereign creation in colour, if we wish to prevent the atrophying of our optical organs.

EASEL PAINTING, ARCHITECTURE AND 'GESAMTKUNSTWERK'

This also puts the role of the controversial easel painting or separate optical structure (in the sense that a book is an autonomous structure with a justification for existence independent of nature or architecture) into its right perspective. As long, indeed, as man, possessing his sensory faculties, desires optical experiences – one could say: for reasons of self-preservation – it will be impossible to dispense with composition in colour harmonies. Until recently, it is true, people thought otherwise. They affirmed that the easel painting was doomed to extinction, since it was disintegrating in the anarchy of subjective vision; for our age with its aspirations towards collective thought and action demands objective laws of creation. With the demand for collective composition came recognition of the need for colour-harmonies, with the special application that the painter's sole mission should be to use his knowledge of colour to underline the intentions of the architect.

This crass demand challenging the isolated paintings of *l'art pour l'art* was only a mark of reaction which was quickly superseded by a more general consideration, and one which appears to us to have greater validity: that no material, no field of activity, can be judged from the special character of other materials, other fields, and that painting or any optical creation has its special laws and missions independently of all others.

●

The view of life held by the previous generation was that man has to live his workaday life and that only in his leisure hours may he occupy himself with the phenomena of 'artistic' creation, with its 'spiritually refined' works. As time went on this view led to untenable positions. Thus for example in painting: instead of judging a work in the light of its expressional law, of its rootedness in the life of a collective entity,

16

purely personal standards were applied and matters of universal concern were dismissed as individual fancy. This excessively subjective attitude of the recipient reacted upon many artists in such a way that they gradually forgot how to produce the essential, the work with a biological basis and, their purpose instead now being to 'create works of art', they seized upon the trivial, the unimportant and often upon aesthetic formulae *derived* historically or subjectively from the great individual works. The opposition which emerged to this decline of painterly creation **(Cubism, Constructivism)** tried to purify *the expressional elements and means themselves* without *intending* to produce 'art' in the process. 'Art' comes into being when expression is at its optimum, i.e. when at its highest intensity it is rooted in biological law, purposeful, unambiguous, pure●). The second way consisted in an attempt to bring together into one *entity* singular works or separate fields of creation that were isolated from one another. This entity was to be the 'Gesamtkunstwerk', architecture, the sum of all the arts. (The De Stijl Group, Holland; first period of the Bauhaus.) The concept of a total work of art was readily intelligible, yesterday, at the period when specialisation was at its height. With its ramifications and its fragmenting action in every field, specialisation had destroyed all belief in the possibility of embracing the totality of all fields, *the wholeness of life*. Since, however, the *Gesamtkunstwerk* is only an addition, albeit an organised one, we cannot be satisfied with it today. What we need is not the *'Gesamtkunstwerk'*, alongside and separated from which life flows by, but a synthesis of all the vital impulses spontaneously forming itself into the all-embracing *Gesamtwerk* (life) which abolishes all isolation, in which **all individual** accomplishments proceed from a biological necessity and culminate in a **universal** necessity.

The principal task of the next period will have to be to create each work in conformity with its own laws and its own distinctive character. The unity of life cannot emerge when the boundaries of the works created are

●) Children's drawings, as far as the child itself is concerned, are usually optimal productions. This optimum is therefore relative. In contrast to this, the work of an artist, a man 'in the deepest sense' creative, is an optimum not only for himself alone, but for the generality, for humanity, because by enriching everything, it carries contents which, but for the work, could scarcely have been brought into our experience with similar intensity.

artificially blurred into one another. **Rather will unity have to be pro-
duced by conceiving and carrying out every creation from within its
fully active and therefore life-forming propensity and fitness.** Carried
out by people whose view of life permits every individual to reach the
highest productivity in his work as it bears on the whole, because he is
allowed time and space to develop also those qualities which are most
personal to himself. In this way man learns again to react to the slightest
stimuli of his own being as well as to the laws of material.

On the basis of a theory of composition which says that a work of art
should be created solely out of means proper to itself and forces proper to
itself, the next step would be an architectonic composition arising as a
synthesis out of the functional elements proper to architecture – therefore
including material-colour – that is, out of the combination based on func-
tion of co-ordinated forces. Such composition would make it possible to
obtain the desired colour-scheme of the rooms and building complexes
without the collaboration of the painter in the modern sense, since func-
tional use of the building material: concrete, steel, nickel, artificial mater-
ials, etc., can unequivocally provide the colour-scheme of the room and
of the whole architecture. On an ideal plane, where biological and tech-
nical functions meet, this is in fact the case. But practice shows that it is
possible, indeed, even for later ages, very probably essential, to call in the
'painter' – the expert – for the coloured details of the rooms. He will,
admittedly, be able to work only within the delimitations arising out of
the structural requirements. This means that there can be virtually no
question of **sovereign** use of colour. If only because from now on colour
will presumably be used in external architecture simply as an aid to or-
ganisation and in interior architecture to increase the effect of atmosphere
and 'comfort'•).

•) Colour in architecture helps to create a sense of comfort to suit the room and its occu-
pant. It thus becomes a coequal means of spatial composition which can be further supple-
mented by furniture and materials. The origin of contemporary experiments in painting the
walls of rooms in different colours is as follows:
The effect of rooms painted homogeneously is hard. There is too much self-emphasis in their
uniform colour. In such a room the presence of the single colour, whatever it may be, is
constantly with us. When, however, the various walls are painted in various harmonising

This means – since the ideal plane can never be realised – a practical application drawn from the complexities of colour composition, while colour composition itself as the sovereign expression of a man in his spiritual and physical essence must develop further along its biological path, beyond the transient truth of form-determining events.

●

Against the idea that the easel painting denotes a decline in comparison with the painting of the great frescos, we may argue that, on the contrary, manuscript and bible illustrations, easel paintings, landscapes, portraits, etc., were revolutionary achievements viewed from the angle of **representation.** Since the discovery of the laws of perspective, the easel painting has neglected colour as such and has addressed itself almost wholly to representation. This has reached the zenith of its representational intentions in photography, but at the same time, of course, the nadir of colour composition.

The Impressionists were the first to give colour back to civilised man. This development of the easel painting has led to a clear division between colour and representational composition.

colours it is only the *relationships* of the colours which operate. A resonance arises which displaces colour as a self-accentuated material and creates instead an effect in which colour relationships alone play a part. This gives the whole room a sublimated, atmospheric quality: comfortable, festive, diverting, concentrating, etc. Some system in the choice and distribution of colour is determined by the room and its function (hygiene, lighting technique, communication, etc.). It follows that the habit of painting walls in different colours cannot be indulged everywhere indiscriminately.

STATIC AND KINETIC OPTICAL COMPOSITION

The development of new technical means has resulted in the emergence of new fields of creativity; and thus it is that contemporary technical products, optical apparatus: the spotlight, the reflector, the electric sign, have created new forms and fields not only of representation but also of *colour composition*. Pigment has hitherto been the major means of colour composition, has been recognised as such and used both for easel painting and in its capacity of 'building material' in architecture. The medieval stained-glass window alone marks a different notion, but one that was not consistently carried through. These windows produced a certain amount of radiant spatial reflection in addition to the colours of the planes. The moving, coloured figures (continuous light displays), however, which are today deliberately screened with a reflector or projector open up new expressional possibilities and therefore new laws.

For centuries efforts have been made to produce a light-organ or a colour-piano. The experiments conducted by *Newton* and his pupil Father *Castel* are famous. The same problem has engaged the attention of many savants since their day. In our time the experiments of *Scriabin* have been pioneer-works. He accompanied his Prometheus Symphony, first performed in New York in 1916, with beams of colour simultaneously projected into the room by means of spotlights. Thomas *Wilfred's Clavilux* (America, c.1920) was an apparatus resembling a laterna magica with which changing non-objective pictorial variations were shown. The efforts of Walter *Ruttman* (Germany), who early enlisted the aid of the film camera in his experiments, represented an important advance in this direction. Most important, however, were the works of **VIKING EGGELING** (Sweden), who died prematurely. Eggeling – the first after the Futurists to do so –

further developed the importance of the time problem, which revolutionised the whole existing aesthetic and formulated a scientifically precise set of problems (p. 119). On an animation desk he photographed a sequence of movements built up from the simplest linear elements and, by correctly estimating developmental relationships in size, tempo, repetition, discontinuity, etc., tried to render the complexity which grows out of simplicity. His experiments at first borrowed from the complexities of musical composition, its division of time, regulation of tempo and its whole structure. But he gradually began to discover the vision-time element and thus his first work to be constructed as a drama of forms became an ABC of motion phenomena in chiaroscuro and variation of direction.

In Eggeling's hands the original colour-piano became a new instrument which primarily produced not colour combinations but rather the *articulation* of *space in motion*. His pupil Hans Richter has – so far only theoretically – emphasised the time-impulse even more strongly and has thus come near to creating a light-space-time continuity in the synthesis of motion. This beginning, long out-dated in theory, has so far failed to handle 'light'. The effect of the works has been that of animated drawings.

The next task: light films which could be shot continuously were introduced in the form of the photogram (see pp. 71 to 78) as made by *Man Ray* and myself. The technical horizon of light-space articulation which had previously been difficult to obtain, was thereby widened.

At the Bauhaus *Schwerdtfeger*, *Hartwig* and *Hirschfeld-Mack* worked with reflected light and shadow plays which in the overlapping and movement of coloured planes represent the most successful practical moving colour-compositions yet. Hirschfeld-Mack's intensive work has produced equipment specially designed for shooting continuous film. He was the first to reveal the profusion of the most delicate transitions and unexpected variations of *coloured* planes in *motion*. A movement of planes, prismatically controllable, which dissolves, conglomerates. His latest experiments go far beyond this point, which resembles the colour-organ in character. The establishment of a new space-time dimension of radiating light and controlled movement becomes ever clearer in his spinning and plunging bands of light. The pianist Alexander László has pursued a similar course with his 'colour-light music'. His experiment is somewhat

obscured by the historical theory which accompanies it. He relies too much upon subjective statements describing his visualisation of colour and sound rather than upon scientific and objective exploration of optophonetic principles. His work is, however, valuable for having produced an apparatus that could also be used outside his experimental field.●)

Despite these experiments, far too little work has so far been done in the field of moving light display. It must at once be tackled from many angles and carried forward as a *pure* discipline. While I value what their experiments have achieved, I consider it a mistake to try, as Hirschfeld-Mack (see pp. 80–85) and A. László do, to combine optical-kinetic with acoustic-musical experiments. A more perfect, because scientifically grounded, performance is promised by Optofonetik. The bold imagination of the Dadaist Raoul Hausmann, has been responsible for the first steps toward a future theory.●●)

Profoundly pertinent, therefore, to the problem of easel painting is, the other urgent question: is it right, today, in the age of moving reflected light phenomena and of the film, to continue to cultivate the static individual painting as a colour composition?

●) In contrast to the earlier theoreticians of the colour-piano, László's idea is that a colour has its equivalent not in one sound but in a whole complex of sounds. His colour-light piano is worked by a second person who projects the colours on to a screen while he himself keeps time upon the piano. The colour-light piano consists of an instrument panel with keys and stops like a harmonium, to which 4 large and 4 small projectors are fixed. The figures on the slides produced by the Uvachrom process represent the actual motifs, which are projected by means of 8 colour-prisms into the ground colours (in each of the 4 large projectors 8 colour-prisms) by subtractive or additive mixing. The 4 large projectors fitted with triple condensers are equipped with:
1. revolving cross-frames for moving the slides vertically and horizontally,
2. a tall cylinder between the bellows and lens to move the 8 colour-keys up and down,
3. a dynamic (iris-) diaphragm to regulate the intensity of the light and the light-effects.
4. a delimiting diaphragm (in front of the lens).
The actual pictorial motifs originate in the 4 small projectors which, following existing procedures for showing slides, change and are switched on and off.
●●) Inspired by Hausmann's efforts, *Walter Brinkmann* has worked on the same problem. His description of 'audible colours' which follows will provide a fuller explanation: 'The

The essence of the individual painting is the production of tensions and (or) formal relations on the picture plane, the production of new, coloured harmonies in a state of equilibrium. The essence of the reflected light play is the production of light-space-time tensions in colour or chiaroscuro harmonies and (or) in various forms by kinetic means, in a continuity of motion: as an optical passage of time in a state of equilibrium.

The newly emergent impulse of time and its ever expanding articulation here produce a state of increased activity in the observer, who – instead of *meditating* upon a static image and instead of immersing himself in it

definitions of elementary physics run much as follows: sounds are 'vibrations of air', but light is 'vibrations of ether'; the diffusion of sound is a process which takes place in material substances and in substances only, whereas the diffusion of light does not take place in substances or at least not only in substances, etc. Thus a negative answer to the question of closer relationships between light and sound would seem from these assumptions already to have been given. Nevertheless, now that we have learnt more about physics – in the light of which we have already accustomed ourselves to regarding optics simply as a special province of the theory of electricity and to explaining as many things as possible in terms of electro-dynamics – we no longer baldly assert that any kind of 'correspondence' between the two must be totally impossible.
It is not the first time in physics that hypotheses belonging to other disciplines, including psychology, call for proof that is incontestable on physical grounds and by so doing also point to an extension of physical principles. **The most recent results of 'colour-sound research'** require physical foundation, not, indeed, in mathematical-philosophical speculation, as has frequently been tried, but in *exact investigations* and *experiments* which thus need not shake or violate the principles of physics. Practical possibilities of solving the problem positively would, for example, be afforded if light and sound were to be successfully separated from their bearers – ether and air respectively – or else electrical waves made common bearers of both. This latter possibility is in fact objectively so easy to conceive that it must only be regretted that we have so far not managed to construct an apparatus similar in the optical sense to the sound microphone, that is, a 'light microphone', and that in all human probability we never shall. Because of this, we have for purposes of scientific investigation made an apparatus which in its effect is an almost exact equivalent of a 'light microphone'.
The most essential parts of this system for colour-sound investigation are: the 'La Cour wheel' as known in fast and multiplex telegraphy, with tuning fork circuit-breaker, an electro-magnetic axle coupling, a photo-electric medium (a new type of selenium cell, in which the selenium acts as a ferment with the effect of a catalyst) and a selector disc. The selenium cell serves as variable resistance for the electro-magnetic coupling between the

and only then becoming active – is forced almost to double his efforts immediately in order to be able simultaneously to comprehend and to participate in the optical events. Kinetic composition so to speak enables the observer's desire to participate to seize instantly upon new moments of vital insight, whereas the static image generates these reactions slowly. This indicates that there can be no doubt about the justification of both forms of creation; it lies in the necessity of creating optical experiences: whether they be static or kinetic is a question of polar equalisation and of the rhythm which governs our manner of living●).

'La Cour wheel' and the selector disc. In the state of full exposure the selenium cell allows the current of a constant battery at the intensity required for a firm coupling to flow without interruption, so that the electro-magnet of the axle-coupling is fully charged, the 'La Cour wheel' and selector thus closely coupled and both forced to rotate at the same speed. Thus, when the selector is bisected, a sound corresponding to the frequency of the tuning fork circuit-breaker would be formed in a telephone connected in series. A beam of light of an intensity just strong enough for the selenium cell not to increase its resistance and also to continue freely to yield current of the intensity required for close coupling is then reduced to its fields in a prism and each spectral field then thrown separately on to the selenium cell. Each spectral colour changes the velocity of rotation of the selector disc in relation to the unreduced white beam and brings about a different frequency of exposure in the selenium cell and a different sound in the telephone. With the selector coupled to the driving wheel, the selenium cell ensures complete steadiness and exact regulation of the velocity of rotation of the selector, from, precisely, the frequency at full exposure down to total cessation when the selenium cell is completely darkened, and indeed to the finest gradations of 'gliding' corresponding to the nuances of the different exposures produced by prismatic reduction of a beam.
The development of the film photographed in natural colour and the exploitation and perfection of the principle described above advance in closest association towards the 'musical film', a system which makes the film image itself sonorous and 'music-generating'. For the present, the system of colour-sound research here described offers a means whereby the relationship between the qualities of sound and colour may be accurately investigated.'

●) The same problem of justification crops up between printed literature and radio or talking film and theatre.

DOMESTIC PINACOTHECA

Equal right for every one to *coequal* satisfaction of his needs – such is the goal of all progressive work today. Technology and its capacity for mass production of commodities has to a great extent levelled and raised the niveau of humanity. The invention of printing and the mechanical press means that today almost everyone is in a position to acquire books. The possibilities of reproducing created coloured harmonies: pictures, even in their contemporary form, enable many people to procure stimulating colour compositions (reproductions, lithographs, collotypes, etc.), although the radio picture service as a source of more intensive distribution is probably still to come. There is also the possibility of maintaining a collection of coloured slides in the way that we keep gramophone records.

Contemporary technology offers a means of assuring a wide circulation for 'originals' too. With the aid of machine production, with the aid of exact mechanical and technical instruments and processes (spray-guns, enamelled metal, stencilling) we can today free ourselves from the domination of the individual hand-made piece and its market value.•) Such a picture will obviously not be used as it is today as a piece of **lifeless room-decoration** but will probably be kept in compartments on shelves or 'domestic picture-galleries' and brought out only when they are really needed. Such domestic picture-galleries are common in China and Japan. Collections of prints and drawings have long been

•) Valuable artificial materials are being produced today for the electro-technical industry: turbonite, trolite, neolith, galalith, etc., etc. These materials, like aluminium, cellon, celluloid, are much more suitable for pictures which have to be accurately executed than are canvas and wood-panel. I do not doubt that these or similar materials will soon become the ones most often used for easel paintings and that it will be possible to achieve quite new and surprising effects with them. Experiments with painting on highly polished black panels (trolite), on coloured transparent and translucent plates (galalith, matt and translucent cellon), produce strange optical effects: it looks as though the colour were **floating** almost without material effect in a space in front of the plane to which it is in fact applied.

25

used in this way in Europe too. Just as today we store the film spools for private cinematographs in a cupboard in our home.

It is probable that future development will attach the greatest importance to kinetic, projected composition, probably even with interpenetrating beams and masses of light floating freely in the room **without a direct plane of projection**; the instruments will continually be improved so that it will be able to embrace far larger fields of tension than the most highly developed static picture. The consequence will be that in future periods only the man who actually produces sovereign and uncompromising works will be able to become and remain a 'PAINTER'.

On the other hand, proper handling of reflected (film) and projected composition, which will be the dominant mode in the artistic use of colour in the future, presupposes a thorough knowledge of optics and its mechanical and technical application (as, for example, photography).

It is a surprising fact that today's painter of 'genius' possesses very little scientific knowledge in comparison with the 'unimaginative' technician. The technician has already long worked with this knowledge. Thus from the field of optics he uses, for example, phenomena of interference and polarisation, subtractive and additive blends of light, etc. But that these should be used as much as a matter of course in creating coloured displays seems at present a Utopian idea, despite the fact that the sole argument levelled against their use is a misunderstood appraisal of the process of artistic activity. People believe that they should demand hand execution as an inseparable part of the genesis of a work of art. In fact, in comparison with the inventive **mental** process of the genesis of the work, the question of its execution is important only in so far as it must be *mastered* to the limits. The manner, however – whether personal or by assignment of labour, whether manual or mechanical – is irrelevant.

PHOTOGRAPHY

Although it has spread enormously, nothing essentially new has been discovered in the principle and technique of photography since the process was invented. Every innovation since introduced – with the exception of X-ray photography – has been based on the artistic, reproductive concept prevailing in Daguerre's day (c.1830): reproduction (copy) of nature in conformity with the rules of perspective. Every period with a distinctive style of painting since then has had an imitative photographic manner derived from the painterly trend of the moment (e.g. p. 49).[●])

Men discover new instruments, new methods of work, which revolutionise their familiar habits of work. Often, however, it is a long time before the innovation is properly utilised; it is hampered by the old; the new function is shrouded in the traditional form. The creative possibilities of the innovation are usually slowly disclosed by these old forms, old instruments and fields of creativity which burst into euphoric flower when the innovation which has been preparing finally emerges. Thus for example **Futurist** (static) painting stated the problem of simultaneity of movement, the representation of the time impulse – a clear-cut problem which later brought about its own destruction; and this was at a time when the film was already known but far from being understood. Similarly the **painting** of the **Constructivists** which paves the way for the development on the highest level of reflected light composition such as already exists in embryo.. We can also regard – with caution – some of the painters working today with representational, objective means (Neo-Classicists and painters of the 'Neue Sachlichkeit' movement) as pioneers of a new form of

●) The excellent collection of slides belonging to the Munich photographer E. Wasow convincingly illustrates this statement.

representational optical composition which will soon employ only **mechanical and technical means** – if we disregard the fact that these very works contain tradition-bound, often plainly reactionary elements.

In the photography of earlier days the fact was completely neglected that the light-sensitivity of a chemically prepared surface (glass, metal, paper, celluloid, etc.) was one of the basic elements of the photographic process. This surface was never related to anything other than a camera obscura obeying the laws of perspective, for fixing (reproducing) individual objects in their special character as reflectors or absorbers of light. Nor were the potentialities of this combination ever sufficiently consciously exploited.

For if people had been aware of these potentialities they would have been able with the aid of the photographic camera to *make visible* existences which cannot be perceived or taken in by our optical instrument, the eye; *i.e., the photographic camera can either complete or supplement our optical instrument, the eye.* This principle has already been applied in a few scientific experiments, as in the study of movements (walking, jumping, galloping) and of zoological, botanical and mineral forms (enlargements, microscopic photographs) and other investigations into natural history; but these experiments have remained isolated phenomena, the **interconnections** of which have not been established (p. 50 to 56). We have hitherto used the capacities of the camera in a secondary sense only (p. 57 to 61). This is apparent too in the so-called 'faulty' photographs: the view from above, from below, the oblique view, which today often disconcert people who take them to be accidental shots. The secret of their effect is that the photographic camera reproduces the purely optical image and therefore shows the optically true distortions, deformations, foreshortenings, etc., whereas the eye together with our intellectual experience, supplements perceived optical phenomena by means of association and formally and spatially creates a **conceptual image.** Thus in the photographic camera we have the most reliable aid to a beginning of objective vision. Everyone will be compelled to see that which is optically true, is explicable in its own terms, is objective, before he can arrive at any possible subjective position. This will abolish that pictorial and imaginative association pattern which has remained unsuperseded for centuries and which has been stamped upon our vision by great individual painters.

We have – through a hundred years of photography and two decades of film – been enormously enriched in this respect. **We may say that we see the world with entirely different eyes.** Nevertheless, the total result to date amounts to little more than a visual encyclopaedic achievement. This is not enough. We wish to **produce** systematically, since it is important for life that we create *new relationships*.

PRODUCTION
REPRODUCTION

Without wishing to solve in a sentence all the imponderables of human life, we may say that the composition of a man is the synthesis of all his functional mechanism; i.e., that the man of a given period is most perfect when the functional mechanism of which he is composed – the cells as much as the complex organs – is being used to the limits of its biological capacity. Art brings this about – *and this is one of its most important missions,* for the whole complex of effects depends upon the perfection of the functioning. Art attempts to establish far-reaching **new relationships** between the known and the as yet unknown optical, acoustical, and other functional phenomena so that these are absorbed in increasing abundance by the functional apparatus.

It is a basic fact of the human condition that the functional apparatus craves for further new impressions every time a new exposure has taken place. This is one of the reasons why new creative experiments are an enduring necessity. *From this point of view the creations are valuable only when they produce new, previously unknown relationships.* This is yet another way of saying that reproduction (repetition of existing relationships) *without* enriching points of view must from the special point of view of creative art be considered at best only a matter of virtuosity.

Since production (productive creativity) is primarily of service to human development, we must endeavour to expand the apparatus (means) which has so far been used solely for purposes of reproduction for productive purposes ●).

───────────────────

●) I have investigated this in two spheres: with the gramophone and photography. We can, of course, devise similar programmes for other means of reproduction: for the **talking film** (by Engel, Massole, and Vogt), for the **television (Telehor),** etc. In the case of the **gramophone** the situation is as follows: the business of the gramophone to date has been to repro-

If we desire a revaluation in the field of photography so that it can be used productively, we must exploit the light-sensitivity of the photographic (silver bromide) plate: fixing upon it light phenomena (moments from light-displays) *which we have ourselves composed* (with contrivances of mirrors or lenses, transparent crystals, liquids, etc.). We may regard **astronomical, X-ray** and lightning photographs all as forerunners of this type of composition (p. 63 to 72).

———

duce existing acoustical phenomena. The sound vibrations which have to be reproduced are scratched by a needle on a wax plate and later transposed back into sound from a pressing from that plate with the aid of a membrane.

Expansion of the apparatus for productive purposes might make it possible for scratches to be made in the wax plate by the person himself without mechanical external agency (p. 62); these would, when reproduced, give an effect of sound, which would offer without new instruments and without orchestra a **new way** of generating sound (new sounds which do not yet exist and new sound relationships) and thus help to bring about a change in the concept of music and in compositional possibilities. (See my articles in 'De Stijl' 1922 No.7, in 'Der Sturm' VII/1923 and in 'Broom'[New York] March 1923, 'Anbruch' [Vienna] 1926.)

PHOTOGRAPHY WITHOUT CAMERA

THE 'PHOTOGRAM'

This potentiality can be practically utilised in the following manner: the light is allowed to fall on to a screen (photographic plate, light-sensitive paper) through objects with different coefficients of refraction or to be deflected from its original path by various contrivances; certain parts of the screen are shaded, etc. This process can occur with or without camera. (In the second case the technique of the process consists in fixing a differentiated play of light and shadow).

This course leads to possibilities of *light-composition*, in which light must be sovereignly handled **as a new creative means,** like colour in painting and sound in music. I call this mode of light-composition the **photogram.** (See p. 71 to 78.) It offers scope for composing **in a newly mastered material.**

Another way of moving towards productivity might be to investigate and utilise various chemical compositions which can fix light phenomena (electro-magnetic vibrations) invisible to the eye (like, for example, X-ray photography).

Yet another way is to construct new cameras, first of all using the camera obscura, secondly eliminating perspectival representation. Cameras with systems of lenses and mirrors which can encompass the object from all sides at once and cameras which are constructed on optical laws different from those of our eyes.

THE FUTURE OF THE PHOTOGRAPHIC PROCESS

Creative use of this knowledge and these principles will silence those who contend that photography is not an 'art'.

The human mind everywhere finds fields in which it can work creatively. Thus we shall very soon have to record great progress in the field of photography too.

Photography when used as a **representational art** is not a mere copy of nature. This is proved by the rarity of the 'good' photograph. Only now and then does one find really 'good' photographs among the millions which appear in illustrated papers and books. What is remarkable in this and at the same time serves as proof is that (after a fairly long visual culture) we always infallibly and with sure instinct discover the 'good' photos, quite apart from the novelty or unfamiliarity of the 'thematic' content. We have gained a new feeling for the quality of chiaroscuro, shining white, transitions from black to grey imbued with fluid light, the precise magic of the finest texture: in the framework of steel buildings just as much as in the foam of the sea – and all fixed in a hundredth or thousandth fraction of a second.

Since as a rule light phenomena offer greater possibilities of differentiation in motion than in the static condition, all photographic processes reach their highest level in the film (relationships between the motions of the light projections).

Film practice has so far been largely restricted to reproducing dramatic action without, however, fully utilising the potentialities of the camera

in an imaginatively creative manner. The camera as a technical instrument and the most important productive factor in film-making copies the objects in the world around us in a manner that is 'true to nature'. We must be prepared for this; but we have hitherto been too fully prepared, with the result that the important other elements in film-making have been insufficiently refined: **formal** tensions, **penetration, chiaroscuro relationships, movement, tempo.** Thus film-makers have lost sight of the possibility of using objective elements in a conspicuously *filmic* manner and have usually stuck to reproducing works of nature and stage-plays.

Most of our contemporaries have the outlook of the age of the first steam locomotives. *Modern* illustrated papers are still behind the times – compared with their vast potentialities! And what educational and civilising work they could and should perform! Impart the wonders of technique, of science, of the intellect. In large matters and small, both distant and near at hand●). In the field of photography there is undoubtedly a whole series of important works which show us the inexhaustible wonders of life. This has hitherto been the mission of painters of all ages. But already many are filled with a sense of the inadequacy of the old representational means. This is why many attempts on the part of *painters* to show the things of the world objectively represent an important success for the interrelationship between photography and the painter's art. The reproduction of present-day standard forms in such pictures will however appear as crude experiments in representation once photographic materials are properly handled, in the most delicate tones of grey and brown, with the enamel bloom of the glossy photographic paper. When photography gains full recognition of its *own* true laws, representational composition will reach a peak and a perfection which could never be achieved by craft (manual) means.

To proclaim that our optical senses have been fundamentally enriched by new creative principles in painting and the film still produces a revolutionary effect. Most people still stick far too fast to the continuity of development of the manual imitative craft work *ad analogiam* classical pictures to be able to grasp this complete reorganisation.

●) A certain improvement in this respect may be noted since the first edition of this book appeared.

But he who does not fear today to follow the path that will be unavoidable tomorrow is providing himself with the basis of truly creative work. Both in photographic art (film) and in painterly (including non-objective) art his **clear understanding of the means** permits him to respond to the reciprocal stimuli and thus to make full use of the means in their ever increasing richness and perfection. I myself have learnt from my photographic work much that is of use in my painting and conversely problems posed by my paintings have often enough provided hints for my photographic experiments (p. 75). It is in general true that the emergence of a filmic art in colour (and sound) will compel historically based imitative *painting* to free itself with increasing confidence from the representation of objective elements in favour of pure colour relationships; and the role of real or super-real or Utopian representation and reproduction of objects – hitherto the concern of painting – will be assumed by photography (film) with its exact organisation of its means.

To try to forge a totality out of today's beginnings – both in photography and abstract painting – would be disastrous; and would also underrate the possibilities of a future synthesis, which will assuredly look different from anything anyone could predict today. An intuitive and logical examination of the problem enables us to observe too that a mechanical and optical art of representation in colour: colour photography or film, will produce results entirely different from the Lumière and other photographs of today. No further trace will then remain of the *kitschhaft* coloured sentimentality of this process of dominating nature. Colour photography, like the sound-picture and optophonetic composition, will stand on an entirely new, healthy foundation, even if it takes 100 years of experimentation to bring this about.

The possible uses of photography are already innumerable, for it will enable both the crudest and most delicate effects of light-value – also, when further advances have been made, colour-value – to be fixed. Inter alia in the form of:

records of situations, of reality; (p.86–91)
combination, projection of images on top of one another and side by side;
penetration; compression of scenes to make them manageable: super-reality, Utopia and humour (here is the new wit!);(p. 100–105)

objective but also expressive portraits; (p. 94–99)
publicity; poster; political propaganda; (p. 106–113)
creative means for photo-books, i.e., photographs in place of text; typophoto; (p. 38 and 124–137)
creative means for two- or three-dimensional non-objective absolute light-projections;
simultaneous cinema, etc., etc.

The potentialities of the film include reproducing the dynamic of different movements; scientific and other observations of a functional, chemical type; quick and slow motion pictures; *radio projected film newspaper*. The consequences of exploiting these potentialities include: the development of education, criminology, the whole news-service and much else. What a surprise it would be if, for example, it were possible to film a man daily from birth to his death in old age. It would be most unnerving even to be able to watch only his face with the slowly changing expression of a long life and his growing beard, etc., all in 5 minutes; or the statesman, the musician, the poet in conversation and in action; animals, plants, etc. about their vital functions; here microscopic observation will reveal the profoundest connections. **Even with a proper understanding of the material, speed and breadth of thought do not suffice to predict all the obvious potentialities.**

In order to suggest by way of illustration one of the uses, I show a few photoplastics (p. 108–110). They are pieced together from various photographs and are an experimental method of simultaneous representation; compressed interpenetration of visual and verbal wit; weird combinations of the most realistic, imitative means which pass into imaginary spheres. They can, however, also be forthright, tell a story; more veristic 'than life itself'. It will soon be possible to do this work, at present still in its infancy and done by hand, mechanically with the aid of projections and new printing processes.

To some extent this is already done in current film practice: transillumination; one scene carried over into another; superimposition of different scenes. The iris and other diaphragms can be variously set to link together disconnected parts of events by means of a common rhythm. One sequence

of movement is stopped with an iris diaphragm and the new one is started with the same diaphragm. A unity of impression can be achieved with shots divided into horizontal or vertical strips or shifted upwards to the half; and much else. New means and methods will, of course, enable us to do a great deal more.

The cutting out, juxtaposing, careful arranging of photographic prints as it is done today is a more advanced form (photoplastic, p. 108–112) than the early glued photographic compositions (photomontage) of the Dadaists (p. 106–107). But not until they have been mechanically improved and their development boldly carried forward will the wonderful potentialities inherent in photography and the film be realised.

TYPOPHOTO

Neither curiosity nor economic considerations alone but a deep human interest in what happens in the world have brought about the enormous expansion of the news-service: typography, the film and the radio.

The creative work of the artist, the scientist's experiments, the calculations of the business-man or the present-day politician, all that moves, all that shapes, is bound up in the collectivity of interacting events. The individual's immediate action of the moment always has the effect of simultaneity in the long term. The technician has his machine at hand: satisfaction of the needs of the moment. But basically much more: he is the pioneer of the new social stratification, he paves the way for the future.

The printer's work, for example, to which we still pay too little attention has just such a long-term effect: international understanding and its consequences.

The printer's work is part of the foundation on which the *new world* will be built. Concentrated work of organisation is the spiritual result which brings all elements of human creativity into a synthesis: the play instinct, sympathy, inventions, economic necessities. One man invents printing with movable type, another photography, a third screen-printing and stereotype, the next electrotype, phototype, the celluloid plate hardened by light. Men still kill one another, they have not yet understood how they live, why they live; politicians fail to observe that the earth is an entity, yet television (Telehor) has been invented: the 'Far Seer' – tomorrow we shall be able to look into the heart of our fellow-man, be everywhere and yet be alone; illustrated books, newspapers, magazines are printed – in millions. The unambiguousness of the real, the truth in the everyday situation is there for all classes. **The hygiene of the optical, the health of the visible is slowly filtering through.**

What is typophoto?
Typography is communication composed in type.
Photography is the visual presentation of what can be optically apprehended.
Typophoto is the visually most exact rendering of communication.

Every period has its own optical focus. Our age: that of the film; the electric sign, simultaneity of sensorily perceptible events. It has given us a new, progressively developing creative basis for typography too. Gutenberg's typography, which has endured almost to our own day, moves exclusively in the linear dimension. The intervention of the photographic process has extended it to a new dimensionality, recognised today as total. The preliminary work in this field was done by the illustrated papers, posters and by display printing.

Until recently type face and type setting rigidly preserved a technique which admittedly guaranteed the purity of the linear effect but ignored the new dimensions of life. Only quite recently has there been typographic work which uses the contrasts of typographic material (letters, signs, positive and negative values of the plane) in an attempt to establish a correspondence with modern life. These efforts have, however, done little to relax the inflexibility that has hitherto existed in typographic practice. An effective loosening-up can be achieved only by the most sweeping and all-embracing use of the techniques of photography, zincography, the electrotype, etc. The flexibility and elasticity of these techniques bring with them a new reciprocity between economy and beauty. With the development of **photo-telegraphy,** which enables reproductions and accurate illustrations to be made instantaneously, even philosophical works will presumably use the same means – though on a higher plane – as the present day American magazines. The form of these new typographic works will, of course, be quite different typographically, optically, and synoptically from the linear typography of today.

Linear typography communicating ideas is merely a mediating makeshift link between the content of the communication and the person receiving it:

COMMUNICATION TYPOGRAPHY PERSON

Instead of using typography – as hitherto – merely as an objective means, the attempt is now being made to incorporate it and the potential effects of its subjective existence creatively into the contents.

The typographical materials themselves contain strongly optical tangibilities by means of which they can render the content of the communication in a directly visible – not only in an indirectly intellectual – fashion. Photography is highly effective when used as typographical material. It may appear as illustration beside the words, or in the form of **'phototext'** in place of words, as a precise form of representation so objective as to permit of no individual interpretation. The form, the rendering is constructed out of the optical and associative relationships: into a visual, associative, conceptual, synthetic continuity: into the typophoto as an unambiguous rendering in an *optically* valid form. (An experiment, p. 124).

The typophoto governs the new tempo of the new visual literature.

In the future every printing press will possess its own block-making plant and it can be confidently stated that the future of typographic methods lies with the photo-mechanical processes. The invention of the photographic type-setting machine, the possibility of printing whole editions with X-ray radiography, the new cheap techniques of block making, etc., indicate the trend to which every typographer or typophotographer must adapt himself as soon as possible.

This mode of modern synoptic communication may be broadly pursued on another plane by means of the kinetic process, the film.

SIMULTANEOUS OR POLY-CINEMA

A cinema should be built equipped for different experimental purposes in regard to apparatus and projection screen. One can, for example, visualise the normal projection plane being divided by a simple adapter into different obliquely positioned planes and cambers, like a landscape of mountains and valleys; it would be based upon the simplest possible principle of division so that the distorted effect of the projection could be controlled.

Another suggestion for changing the projection screens might be: one in the shape of a segment of a sphere instead of the present rectangular one. This projection screen should have a very large radius and therefore very little depth and should be placed at an angle of sight of about 45° for the viewer. More than one film (perhaps two in the first trials) would be played on this projection screen; and they would not, indeed, be projected on to a fixed spot but would range continually from left to right or from right to left, up and down, down and up, etc. This process will enable us to present two or more events which start independently of one another but will later by calculation combine and present parallel and coinciding episodes.

The large projection screen has the further advantage of representing a process of movement – let us say that of a motor-car – from beginning to end with greater illusion (movement in the second dimension) than the present projection screen on which one image must always be fixed.

I give a schematic **drawing** to make my meaning quite clear

The film about Mr **A** runs from left to right: birth, course of life. The film about the lady **B** runs from the bottom upwards: birth, course of her life. The projection surfaces of the two films intersect: love, marriage, etc. The two films can then either proceed by intersecting in translucent sequences of events or can run parallel; or a single new film about the two people may take the place of the original two. Another film, the third or fourth, about Mr **C** could run simultaneously with the episodes **A** and **B** from the top downwards or from right to left or even in another direction until it can properly intersect or merge with the other films, etc.

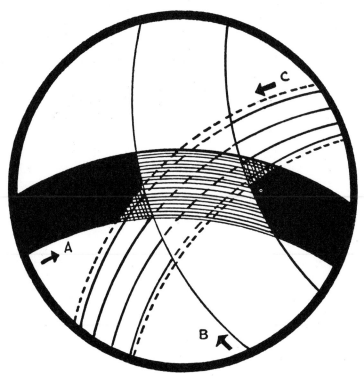

Such a **scheme** will, of course, be just as suitable, if not more so, for non-objective light-projections in the manner of the photogram. If colour effects are used, still richer creative possibilities will arise.

The technical solution to such projections as that of the car or the sketch described above is very simple and not at all costly. **All that is needed is to fit a rotating prism in front of the lens of the film-projector.**

The large projection screen enables us also to repeat a sequence of pictures simultaneously by starting again from the beginning and projecting extra prints of the running film-strip on to the screen through projectors standing next to one another. In this way the beginning of a movement can be shown over and over again as it continues – and is gradually overtaken – and novel effects are thereby achieved.

The realisation of such plans makes new demands upon the capacity of our optical organ of perception, the eye, and our centre of perception, the brain. The vast development both of technique and of the big cities have increased the capacity of our perceptual organs for simultaneous acoustical and optical activity. Everyday life itself affords examples of this: Berliners cross the Potsdamer Platz. They are talking, **they hear simul-**

taneousIy ⁞

> the horns of the motor-cars, the bells of the trams, the tooting of the omnibuses, the halloos of the coachmen, the roar of the underground railway, the shouts of the newspaper sellers, the sounds of a loud-speaker, etc.

and can keep these different acoustical impressions separate from one another. Whereas a provincial, recently found quite disorientated in this Platz, was so greatly confused by the number of impressions that he stood as though rooted to the spot before an oncoming tram. It is obviously possible to construct an analogous situation with optical experiences.

Analogous, too: that modern optics and acoustics, employed as means of artistic creation, can be accepted by and can enrich only those who are receptive to the times in which they live.

ON TECHNICAL POSSIBILITIES AND DEMANDS

The practical prerequisites of an absolute filmic art are excellence of materials and highly developed apparatus.

A prime obstacle to realisation has hitherto lain in the fact that absolute films have been made either by laboriously drawn cartoons or by light–shadow plays which are difficult to shoot. What seems to be needed is a camera which will shoot automatically or otherwise work continuously.

The number of light-phenomena can also be increased by using mechanically *movable sources of light*.

The analogy of light composition in the still picture with or without camera is bound to suggest a variety of devices in the making of a film organised in that way. Thus little movable plates with slits (patterns, etc.) can be slipped between the source of light and the light-sensitive film so that there are continual variations in the exposure of the film. This principle is very flexible and can be used equally in representational (object-) photographs and in absolute light composition.

By studying existing work and asking the right questions one could discover innumerable technical innovations and potentialities. Analysis of optophonetic relationships alone must lead to radically altered new forms. But no amount of study, experimentation, speculation, means anything if it does not spring from inclination and concentration, which are the bases of all creative activity, including photography and the film. We have left behind all that unavoidable fumbling with traditional optical forms; it need no longer impede the new work. We know today that work with controlled light is a different matter from work with pigment.

The traditional painting has become a historical relic and is finished with. Eyes and ears have been opened and are filled at every moment with a wealth of optical and phonetic wonders. A few more vitally progressive years, a few more ardent followers of photographic techniques and it will be a matter of universal knowledge that photography was one of the most important factors in the dawn of a new life.

**IN ADDITION TO THE ESSENTIAL DATA SHORT EXPLANATIONS
HAVE BEEN ADDED TO SOME OF THE FOLLOWING ILLUSTRATIONS**

I have placed the illustrative material
separately following the text because
continuity in the illustrations will make the
problems raised in the text VISUALLY clear.

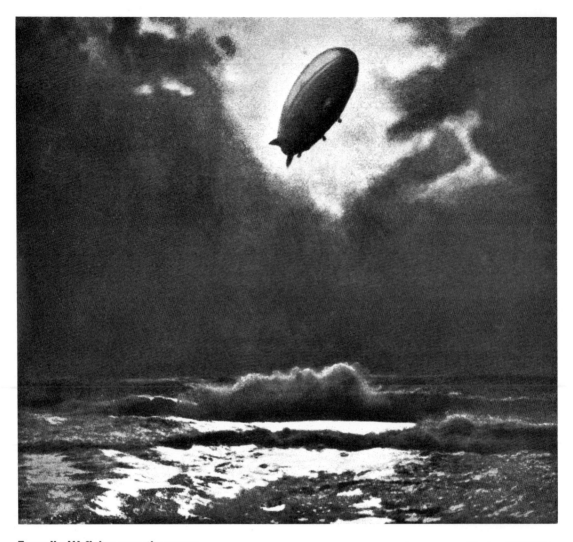

Zeppelin III flying over the ocean

Photo: **GROSS**
From: **Zeitbilder**

This is the 'romantic' landscape. Since the brilliant — but unrepeatable — period of the Daguerreotype the photographer has tried to imitate every trend, style and mode of painting. It took about 100 years before he came to use his own means correctly.

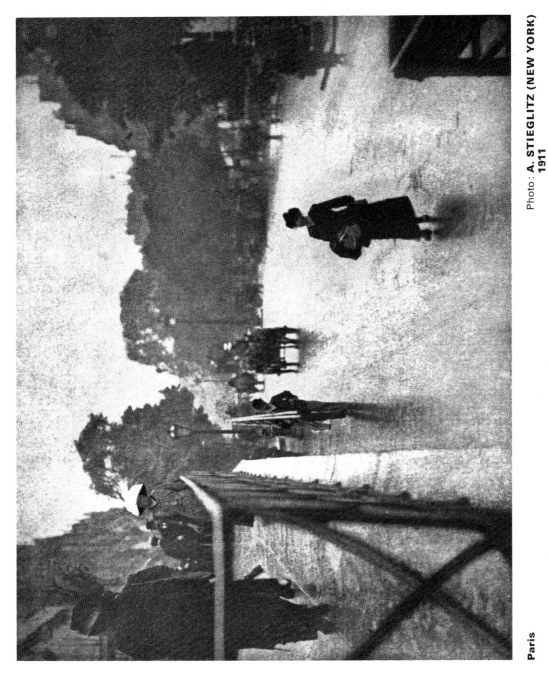

Paris

Photo: **A. STIEGLITZ (NEW YORK)**
1911

The triumph of Impressionism or photography misunderstood. The photographer has become a painter instead of using his camera **photographically.**

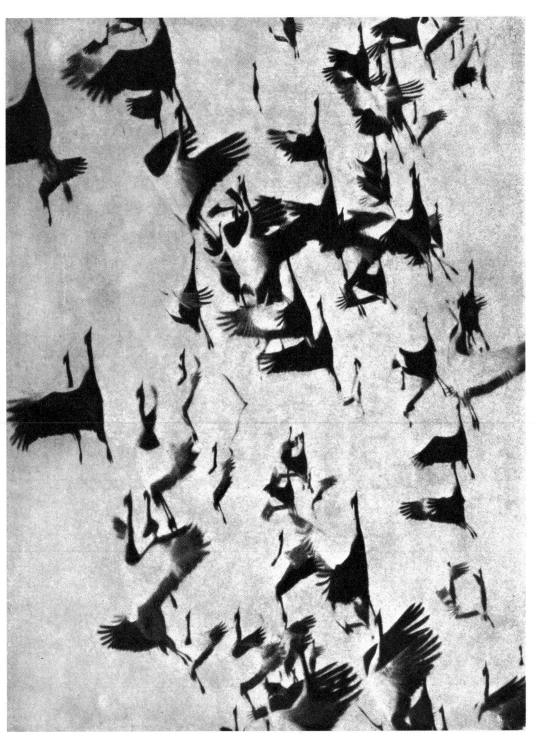

Flock of cranes in flight

A fine organisation of light and shade, effective in itself, apart from the picture motif.

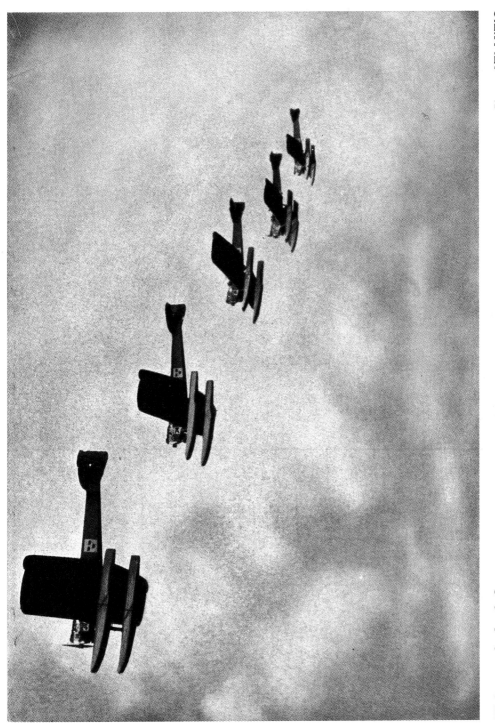

Photo: **ATLANTIC**

Flight over the Arctic Sea

Repetition as a space-time organisational motif, which, in such wealth and exactitude, could be achieved only by means of the technical, industrialised system of reproduction characteristic of our time.

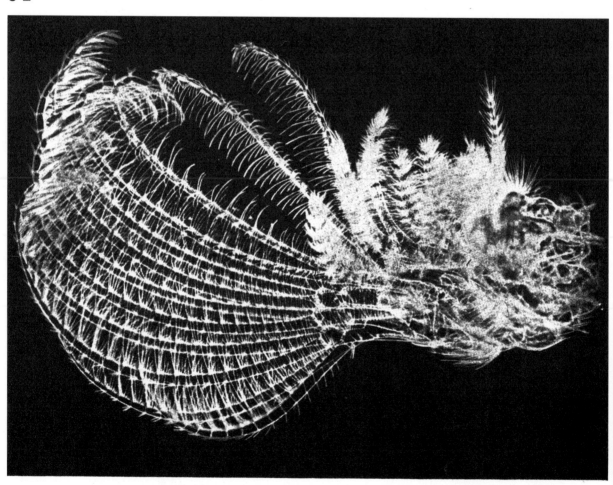

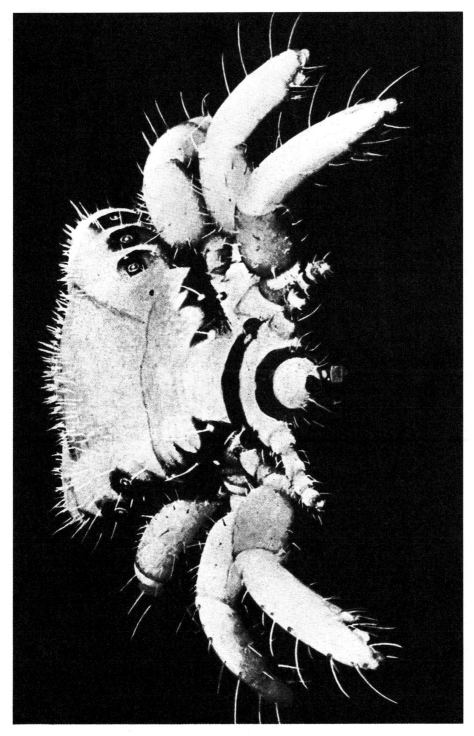

Photo: **ATLANTIC**

Enlarged photograph of a head-louse

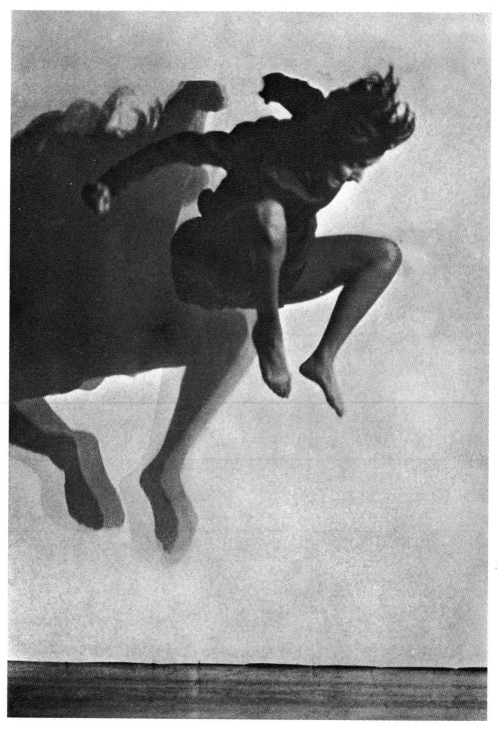

Palucca

Photo : **CHARLOTTE RUDOLF, DRESDEN**

Racing tempo immobilized

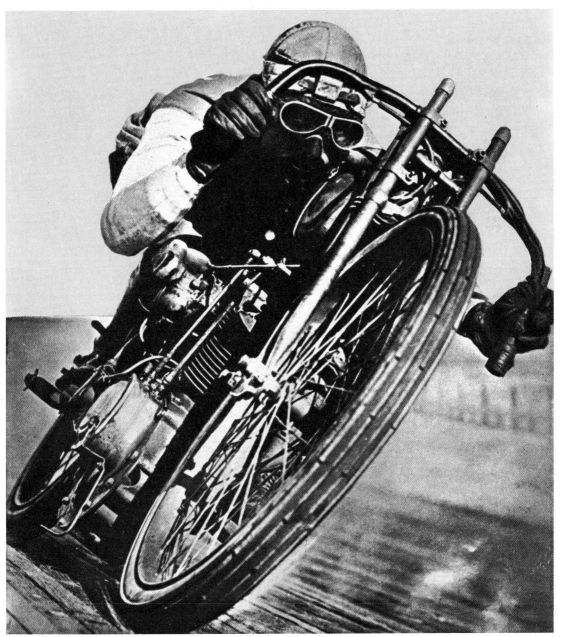

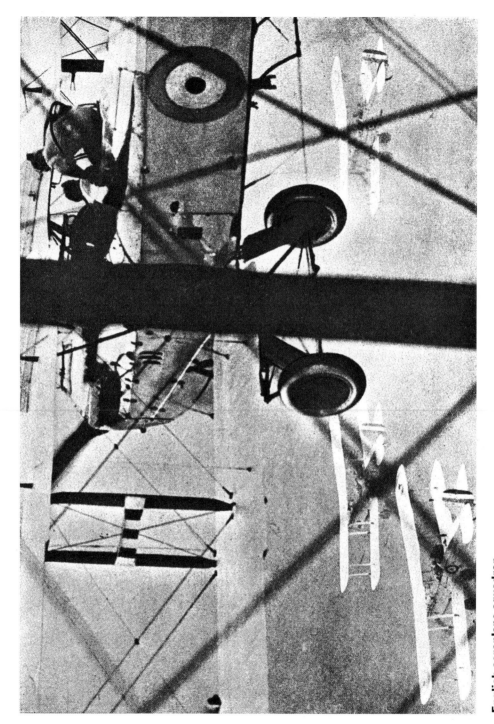

English aeroplane squadron
Photo: **SPORTSPIEGEL**

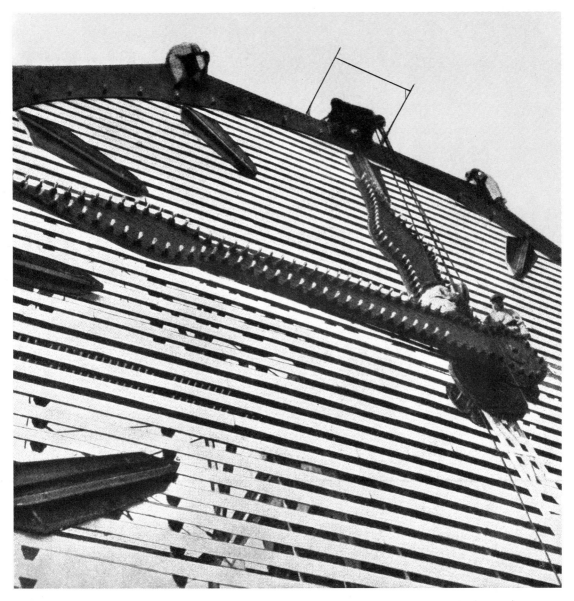

**Repair work on the largest clock in the world
(Jersey City, U.S.A.)**

Photo: **ZEITBILDER**

The experience of the oblique view
and displaced proportions.

St. Paul's Cathedral, London Photo: **ZEITBILDER**

The pews and people photographed through the glass dome.

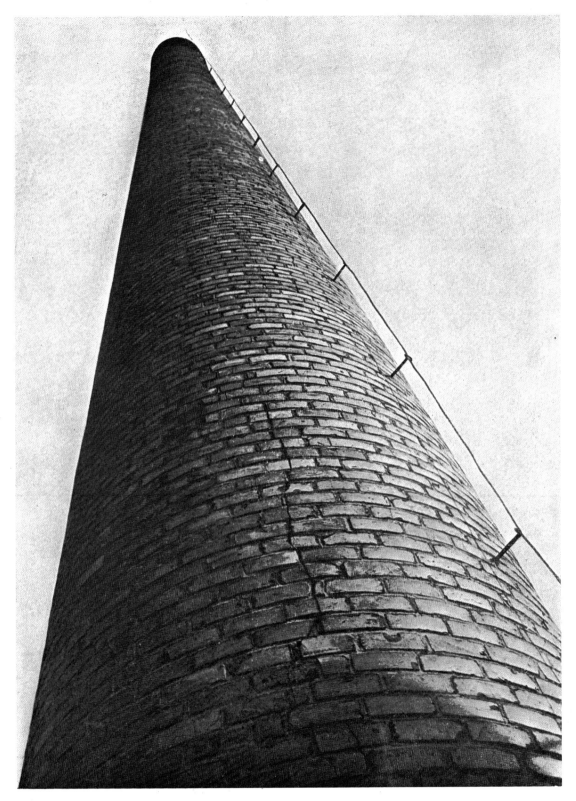

Effect as of animal power
in a factory chimney

Photo: **RENGER-PATZSCH**
Auriga Verlag

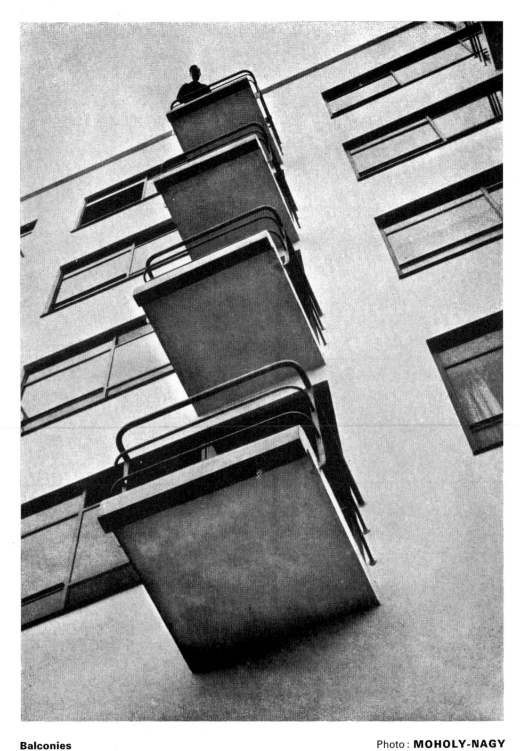

Balconies

Photo: **MOHOLY-NAGY**

The optical truth of the perspectival construction.

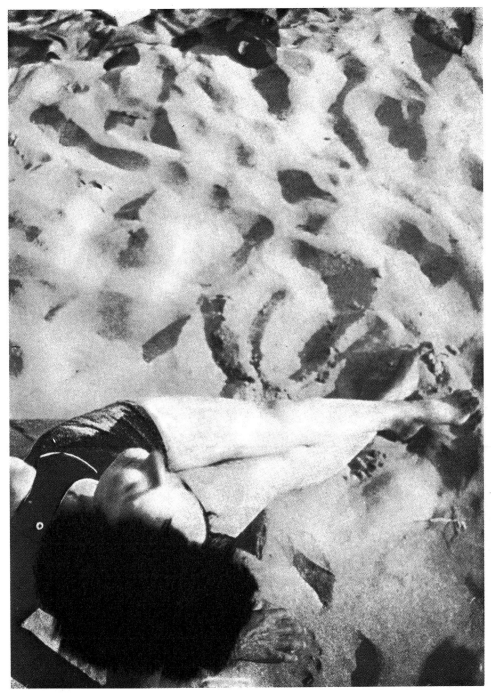

In the sand Photo : **MOHOLY-NAGY**

Formerly regarded as distortion, today a startling experience! An invitation to re-evaluate our way of seeing. This picture can be turned round. It always produces new vistas.

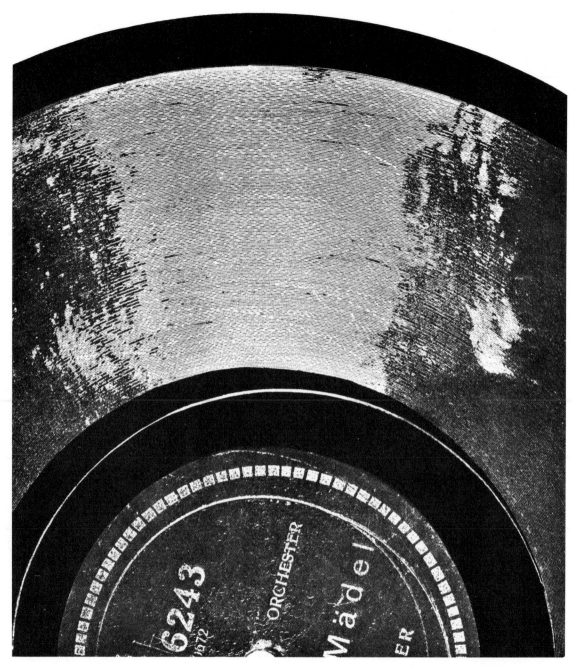

Gramophone record

Heightened reality of an every-day object. A ready-made poster.

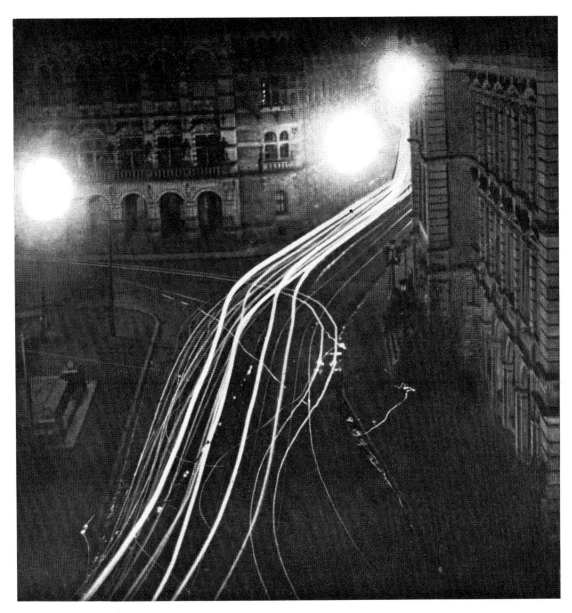

Night shot

Photo : **GRÜNEWALD BREMEN**

The light trails of the passing cars and trams.

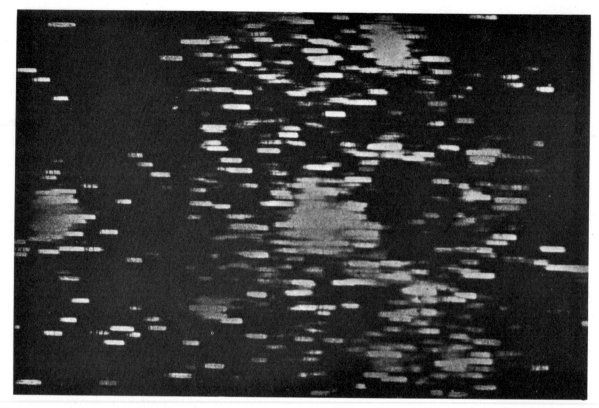

Star spectra photographed with prismatic lens

Photo: **OBSERVATORY AREQUIPA**

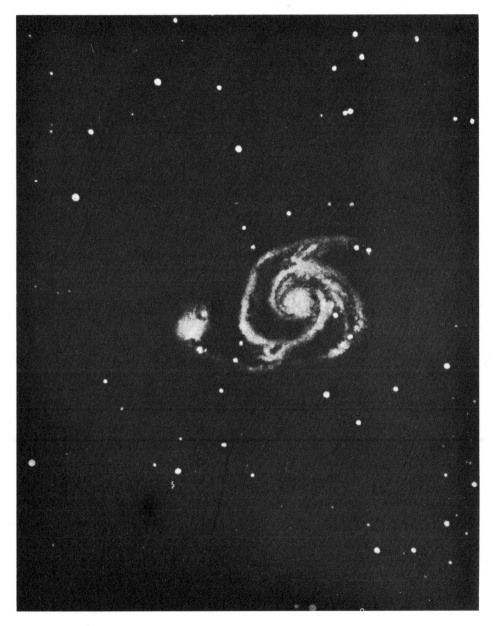

Spiral nebula in the Hounds

Photo: **RITCHEY**

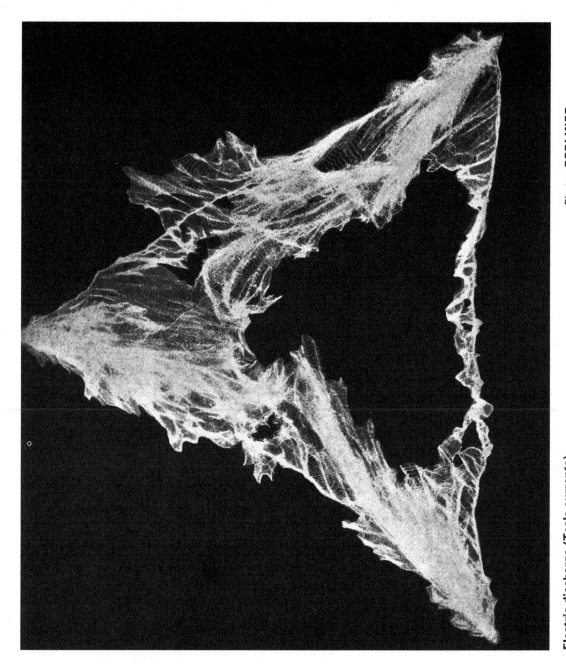

Electric discharge (Tesla currents)
'Solidified fire'.

Photo: **BERLINER ILLUSTRIERTE ZEITUNG**

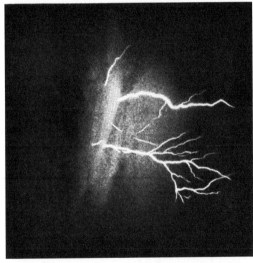

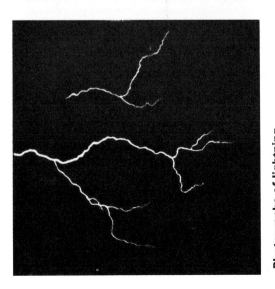

Photographs of lightning

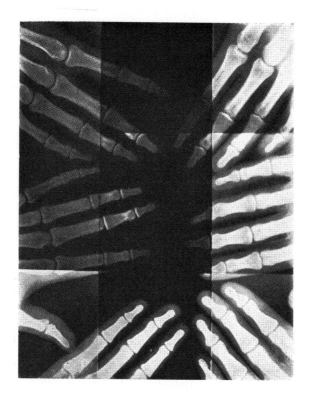

PHOTOGRAPHIC SAMPLES X-ray photo : **AGFA**

From the book :
Einführung in die Röntgenfotografie
by Dr. Phil. John Eggert

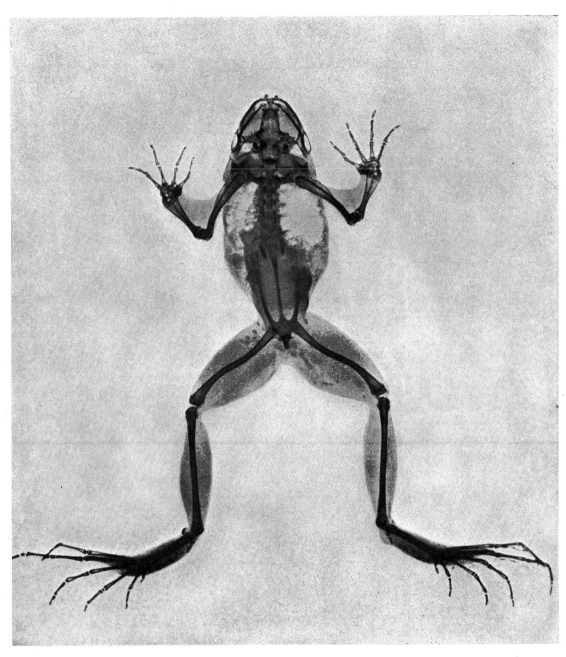

Frog

X-ray photo: **SCHREINER/WEIMAR**

Penetration of the body with light is one of the greatest visual experiences.

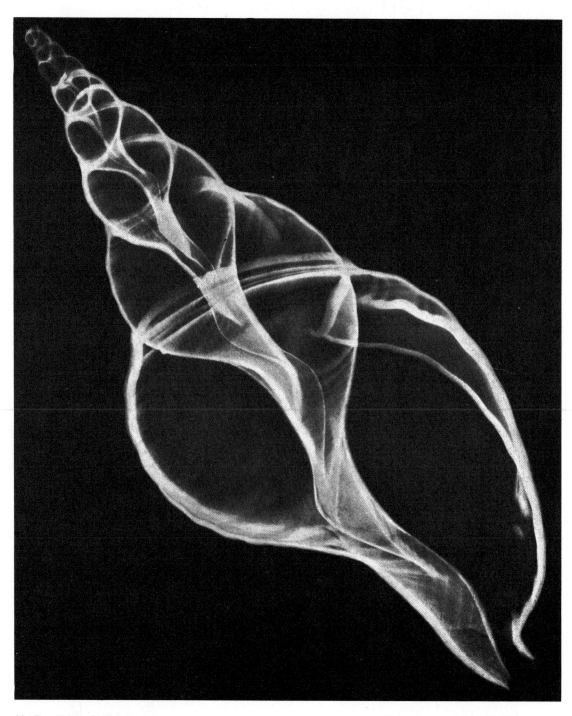

Shell. Triton Tritonis

X-ray photo: **J. B. POLAK**
From: 'Wendingen', Amsterdam

Camera-less photograph Photogram: **MOHOLY-NAGY**

Contrasting relationships between black and white with the finest
transitions of grey.

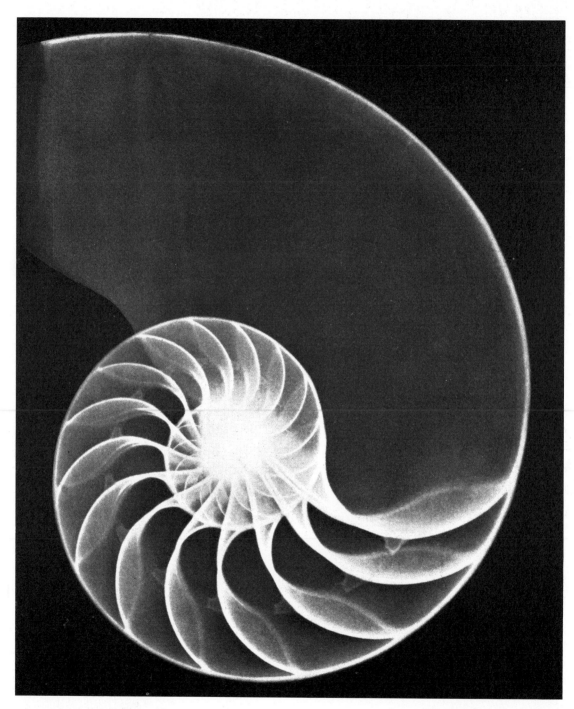

Shell. Nautilus Pompilius

X-ray photo : **J. B. POLAK**
From 'Wendingen', Amsterdam

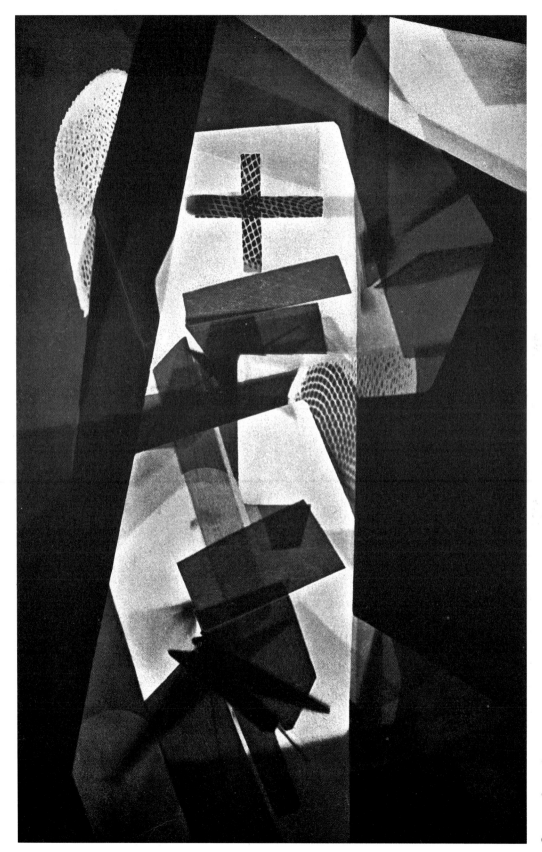

Photogram : **MOHOLY-NAGY**

Camera-less photograph

73

Photogram: **MOHOLY-NAGY**

Camera-less photograph
Organised effects of light and shade bring a new enrichment of our vision.

MOHOLY-NAGY: Construction 'K$^{x'}$ (painting)

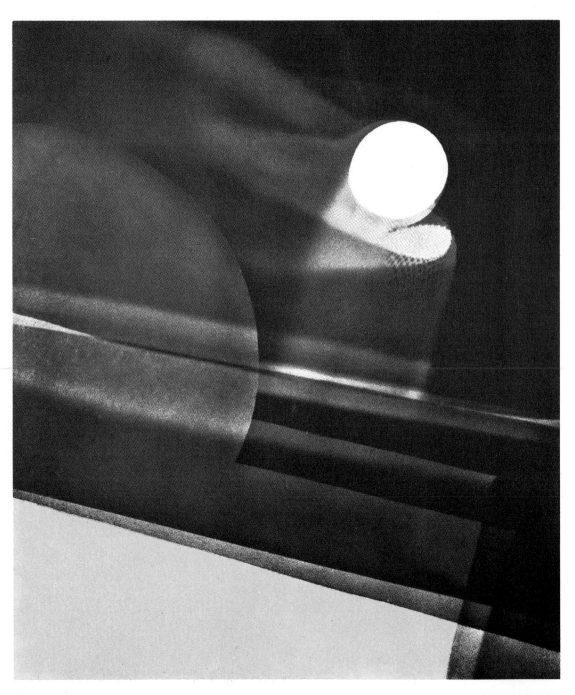

Camera-less photograph

Photogram: **MOHOLY-NAGY**

Camera-less photograph Photogram : **MAN RAY/PARIS**

New use of the material transforms the everyday object into something
mysterious.

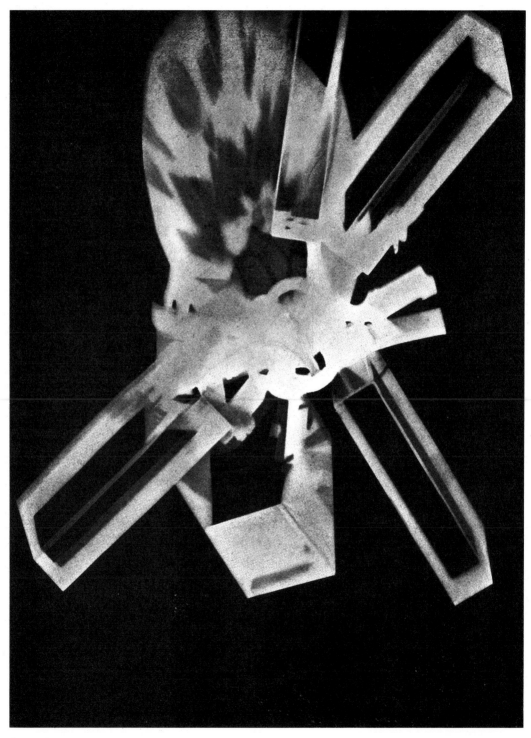

Camera-less photograph

Photogram : **MAN RAY/PARIS**

Photo: **HÜTTICH & OEMLER, WEIMAR**

K. Schwerdtfeger/Bauhaus: Reflected light-displays

A moment in the flow of moving, changing forms.

LUDWIG HIRSCHFELD-MACK writes as follows about his **SCORE** of the **'REFLECTED COLOUR DISPLAYS':**

The reflected colour displays have developed directly from the need to heighten coloured formal planes, which in a painted picture merely simulate a movement through their relationships, into an actual, continuous movement.

Let us look at paintings by Kandinsky or Klee: all the elements for actual movement – tensions from plane to plane to space, rhythm and musical relationships are present in the out-moded painting. It had become a necessity actually to move the colour-form planes. A new technique – direct coloured light projected on to a transparent screen – has enabled us to achieve colours of the most glowing intensity and to create movement by having the sources of light freely movable (sideways in all directions and forwards and backwards in depth) and by opening and shutting apertures in templets. The coloured light is projected through these templets, which are placed between the screen and the sources of light, so that the colours appear now in angular, sharp, pointed forms, in triangles, squares, polygons, now in rounds, circles, arches and undulations. By irradiating over the cones of light, which may involve the whole or parts of the composition, it is possible to make the light-fields overlap and to effect optical mixtures of colour. The working of the apparatus follows an exact **SCORE.**

We have been working for three years on the so-called 'reflected colour displays'. The technique we have developed has had the advantage of the varied resources of the workshops at the Bauhaus as well as of our analysis of the representational means of the film, on which we were engaged even before the colour displays were created. I remember the overpowering impression of the first film I saw in Munich in 1912; the content of the film was tasteless and left me totally unmoved – only the power of the alternating abrupt and long drawn-out movements of light-masses in a darkened room, light varying from the most brilliant white to the deepest black – what a wealth of new expressional possibilities. Needless to say, these primary means of filmic representation – moving light arranged in a rhythmic pattern – was totally disregarded in this film as it is in modern films, in which time and again the literary content of the action plays the principle part. Despite the fact that the music, quite regardless of the film-play, was playing something different, it struck me that a film-play without music lacked something essential, a fact which was confirmed by the restlessness of the others present. I felt at last an unbearable oppression which lifted when the music started again. I account for this observation as follows: *the temporal sequence of a movement can be grasped more readily and accurately through acoustical than through optical articulation. If, however, a spatial delineation is organised in time to become an actual movement, understanding of the temporal sequence will be aided by acoustical means.* The regular ticking of a clock gives a more immediate and more exact feeling of time than the optical appearance, isolated from sound, of the regular movement of the small hand of the watch. This observation also and others, such as the way in which we are absorbed in the element of time when bells ring monotonously, suggests that the above proposition is correct.

80

Anyhow, in recognition of this necessity, I have written music to accompany some of the colour-displays. Lamps, templets and the other auxiliaries are moved in time with the movement of the music, so that the temporal articulation is clearly stated by the *acoustical* rhythm, the *optical* movements as they unfold, contract, overlap, rise and reach climaxes, etc., are underlined and developed.

The formal compositional means are: the moving coloured point, the line and the plane form. Each of these elements may be moved in the desired direction and at the desired speed, enlarged or reduced, projected more brightly or more darkly, with sharp or unsharp outlines, can change colour, can merge with other coloured forms so that optical mixtures occur at the points where the colours overlap (e.g., red and blue become purple). One element can be made to develop out of another, a point can become a line, planes may move so that the plane takes on any desired form. By using dissolving mechanism at the source of light and by the use of resistances we can make both single and larger complexes of coloured forms emerge gradually out of the black background and intensify until they reach the extreme of brilliance and coloured luminosity while other complexes simultaneously disappear and dissolve gradually into the black background. Parts of the composition may be made suddenly to appear or disappear by switching circuit-breakers on or off. These elementary means offer an endless wealth of variations and we strive to use our exact knowledge of them to achieve a *fugue-like, firmly articulated colour-display, which shall proceed at any given time from a specific theme of coloured forms*.

We see in the reflected light-displays the powerful physical and psychical effect of the direct coloured beams combining with rhythmic accompanying music to evolve into a *new artistic genre* and also the proper means of building a bridge of understanding between the many who remain bewildered in the face of the painters' abstract pictures and the new aspirations in every other field, and the new views from which they have sprung.

I reproduce these remarks verbatim but do not identify myself with them in every particular.

L.M.-N.

EXPLANATION OF THE SCORE: COLOUR SONATINA (3 BARS)

1. LINE: Arrangement of bars for the colour-display. Several bars can from time to time be run together to form a larger movement.

2. LINE: Colours. The sonatina begins with white light.

3. LINE: Music.

4. LINE: Position of the movable lamps. During the first part of the sonatina in bar 8–12 the position of the lamps changes into a horizontal position arranged in 2 rows one above the other. The lamps, so adjusted that they can be opened and closed quickly or slowly, are worked by 2 people. They are opened in the order 1, 2, 3, 4, etc. By overlapping the light-beams the fields of light appear in order from the top downwards (see line 9 and compare the sound-movement in line 3).

5. LINE: The templets (plates) are opened in the order 1, 2, 3, 4.

6. and 7. LINE: Main switch and lamp switch.

8. LINE: Resistances. In the 8th vertical column the power gradually cuts out – compare the fading out in the sound line – until the sources of light are completely darkened. The light from lamp 2 only lasts longer – '*d*' in the sound line is held longer – and forms a transition to the new combination in bar 2.

Bar 2, column. 1. It is impossible to see the resistances being switched on for at the moment of darkness all the lamps are closed and only lamp 1 is emitting light.

9. LINE: The over-all picture in lines. The inter-penetrating light-planes are schematically represented by lines.

L. HIRSCHFELD-MACK

COLOUR SONATINA IN THREE PARTS (Ultramarine-green) by Ludwig Hirschfeld-Mack

The first three bars

Tempo ♩ = 50

	BAR 1	BAR 2	BAR 3	BAR 4
1. BAR UNIT				
2. COLOURS	white	white	white	
3. SOUND				
4. LAMPS				
5. TEMPLETS				
6. MAIN SWITCH 1 & 2	1&2on	2-8off	2-8off	1&2
7. LAMP SWITCH 1 to 8X	1&8on			
8. RESISTANCES 1 & 2	1&2on			
9. OVER-ALL PICTURE IN LINES				

STARTING POSITION

LEGEND: ♪ 3/4 time pause ◯◯ switch resistance slowly off ⬤ switch resistance quickly on

→ templet (plate) opens intermittently to the rhythm of the music ⇨ templet (plate) opens gradually — lamp 2 is switched separately.

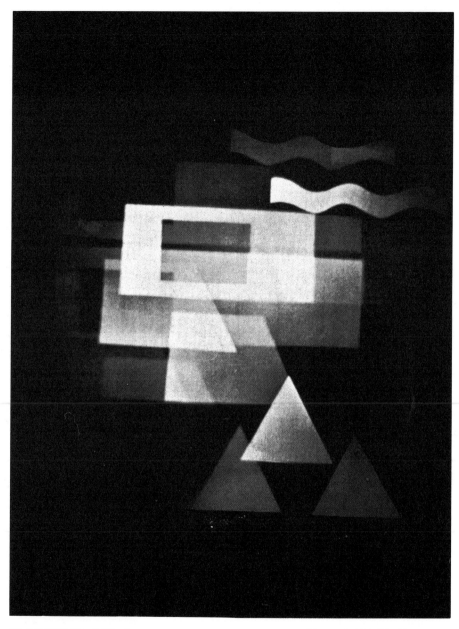

Hirschfeld-Mack/Bauhaus:　　　　　Photo: **ECKNER, WEIMAR**
Reflected light-displays

An arrested moment from the moving display.
The different forms are of different colours and
change colour in the course of the display.

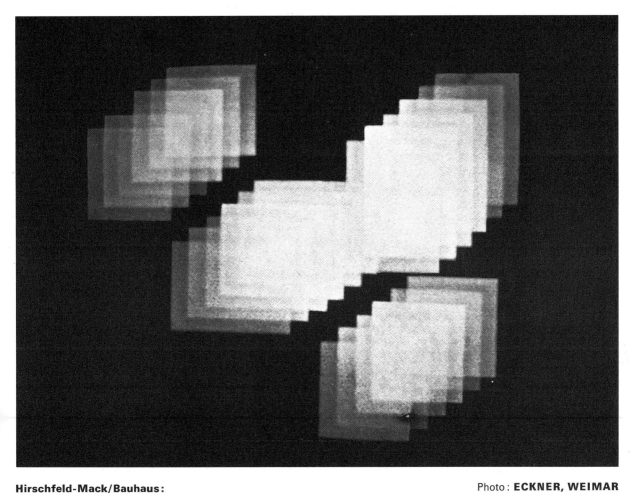

Hirschfeld-Mack/Bauhaus:
Reflected light-displays

Photo: **ECKNER, WEIMAR**

An arrested moment from the moving display.
The individual squares expand in colour in all directions.

Zebras and gnus in East Africa

Photo: **MARTIN JOHNSON**
From the Berliner Illustrierte Zeitung

Photo: **LOHÖFENER**

**Pond-fishing
experimental station, Bavaria.**

Photo: **PRESSFOTO-NEW-SERVICE**
From the Frankfurter Illustrierte Zeitung

There is extraordinary concentration in a singled out detail.

Eye of a marabou

Table-turning

From the Ufa film **'DR. MABUSE'**

The psychological problem of hands – the objective of many painters from Leonardo onwards – caught in a fraction of a second.

Photo : **RENGER-PATZSCH**
Auriga Verlag

Flowering cactus

Cactus

Photo : **RENGER-PATZSCH**
Auriga Verlag

Dolls Photo: **MOHOLY-NAGY**

The organisation of the light and shade, the criss-crossing of the
shadows removes the toy into the realm of the fantastic.

Photograph from above Photo : **MOHOLY-NAGY**

The charm of the photograph lies not in the object but in the view from above and in the balanced relationships.

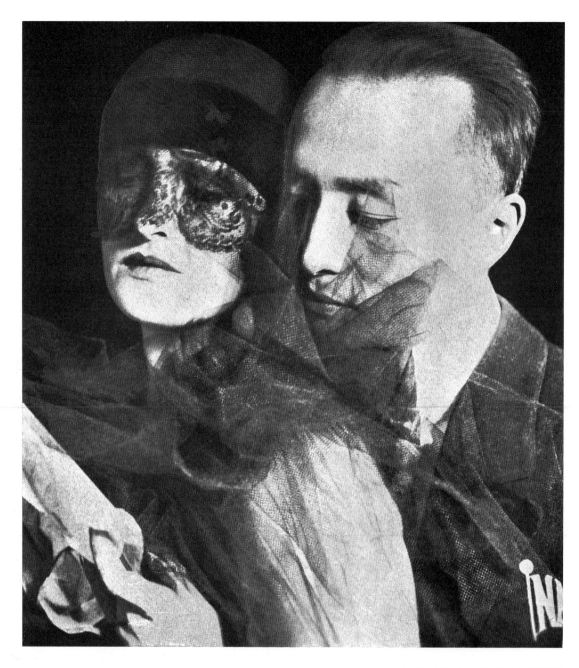

From the film (National) **'ZALAMORT'**

Portrait photograph with rendering of facture effects. (Facture=manner and appearance of the process of production.)

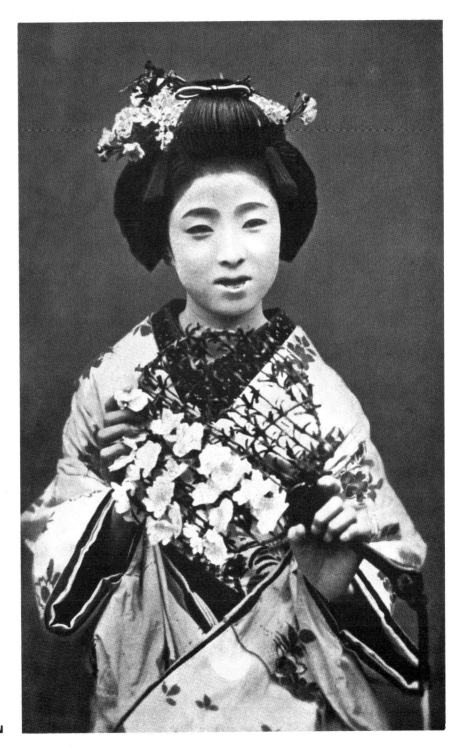

Photo : **FROM JAPAN**

Portrait Photo: **LUCIA MOHOLY**

An attempt at an objective portrait: the individual to be photographed as impartially as an object so that the photographic result shall not be encumbered with subjective intention.

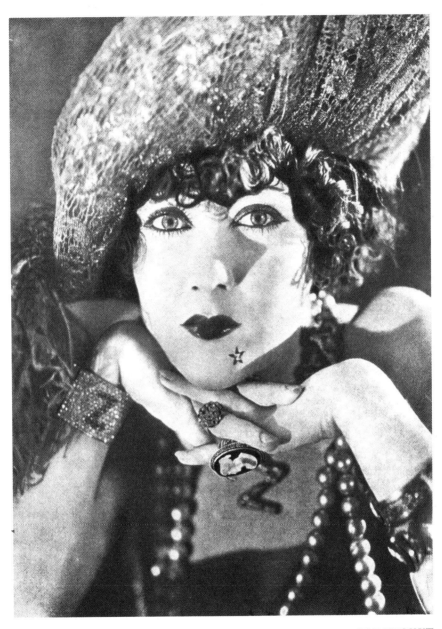

Gloria Swanson Photo : **PARAMOUNT**

American tradition of the portrait photograph : the refined effect
of lighting, materials, factures, roundnesses and curves.

Negative

Photo: **MOHOLY-NAGY**

The transposition of the tone-values transposes the relationships too. The small amount of white becomes most strikingly visible and so determines the character of the whole picture.

Hannah Höch

Rudimentary form of the simultaneous portrait.

Studio in the garden-glass

Photo : **MUCHE/BAUHAUS**

Mirror and reflections

Photo : **MOHOLY-NAGY**

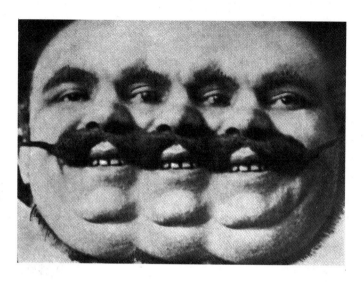

Photo.: **KEYSTONE VIEW CO., LONDON**
From Hackebeils Illustrierter

Arrested laughter in the distorting mirror.

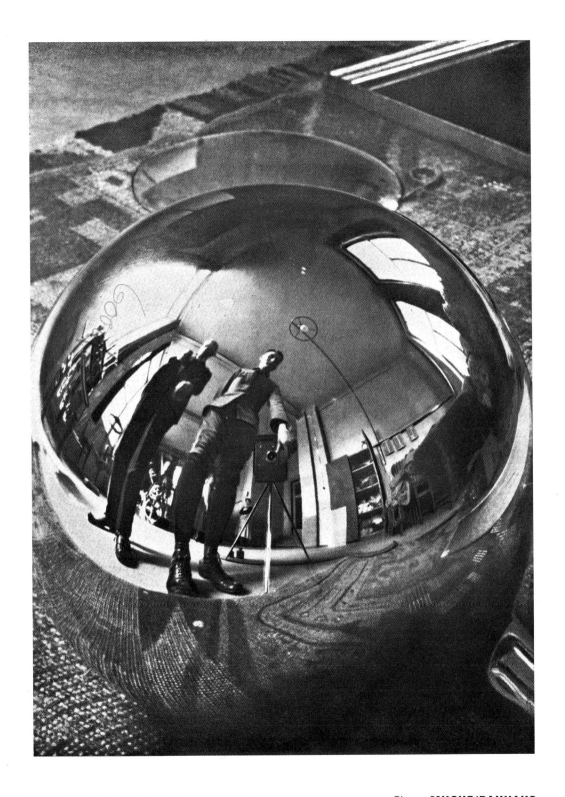

Photographed reflections in a convex mirror Photo : **MUCHE/BAUHAUS**

Horse without end

Photo: **KEYSTONE VIEW CO., LONDON**
From Hackebeils Illustrierter

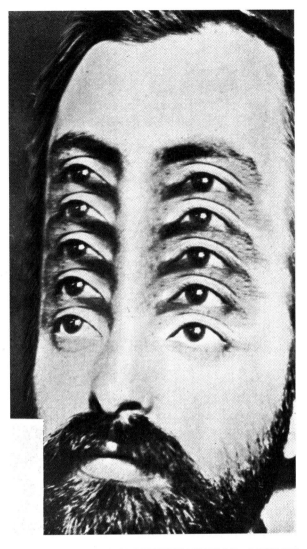

'Superman' or the 'tree of eyes'

Photo : **KEYSTONE VIEW CO., LONDON
From Hackebeils Illustrierter**

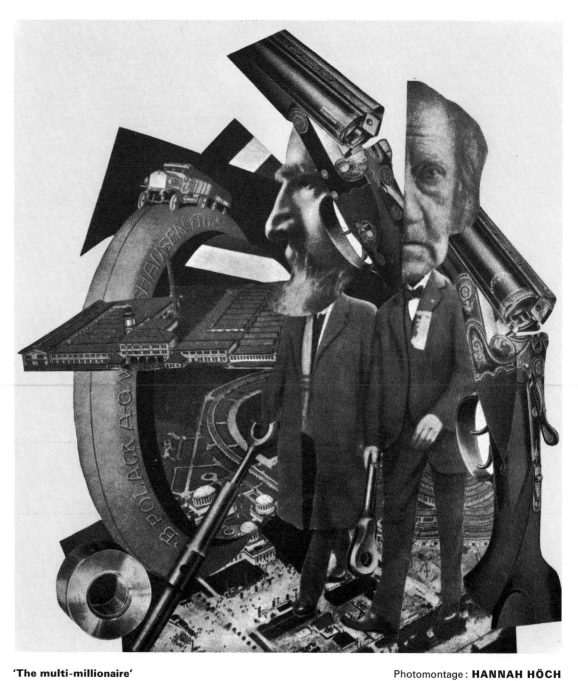

'The multi-millionaire'

Photomontage: **HANNAH HÖCH**

The dual countenance of the ruler.

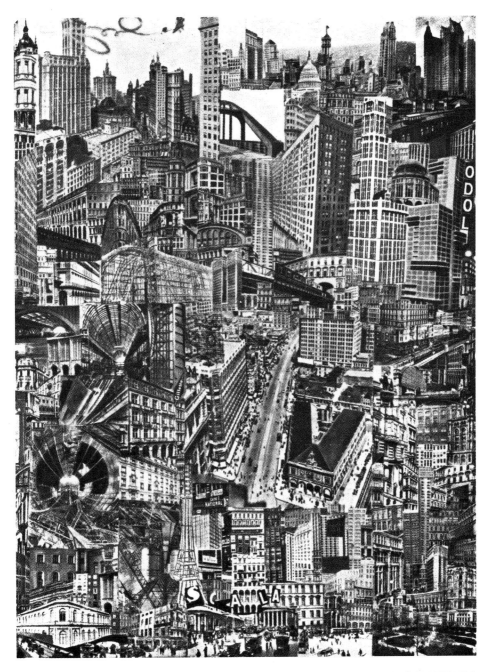

'The City' Photomontage: **CITROEN/BAUHAUS**

The experience of the sea of stone is here raised to gigantic proportions.

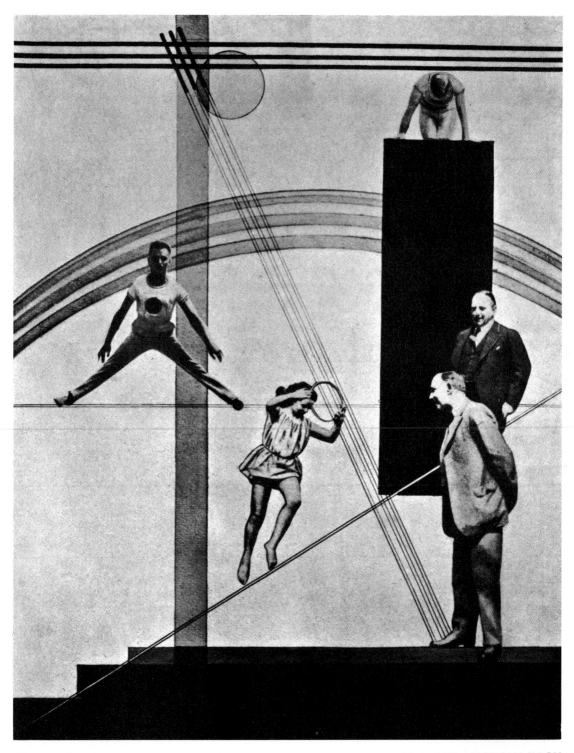

Circus and variety poster Photoplastic: **MOHOLY-NAGY**

Combinations of the possible produce a richness of tension.

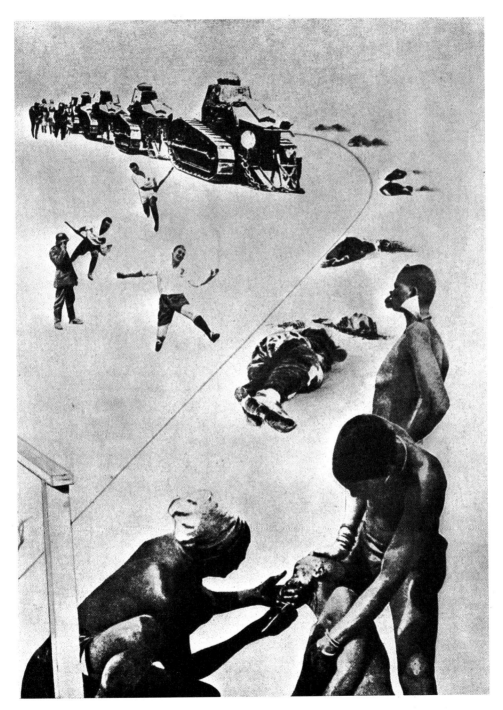

'Militarism'
Propaganda poster.

Photoplastic : **MOHOLY-NAGY**

**Design for the title-page of the journal
'Broom' NEW YORK. 1922**

Typophoto : **MOHOLY-NAGY**

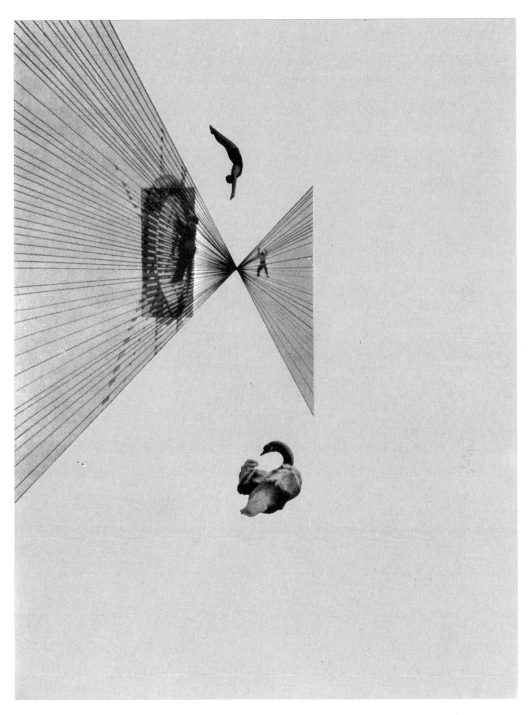

Leda and the swan
The myth inverted.

Photoplastic : **MOHOLY-NAGY**

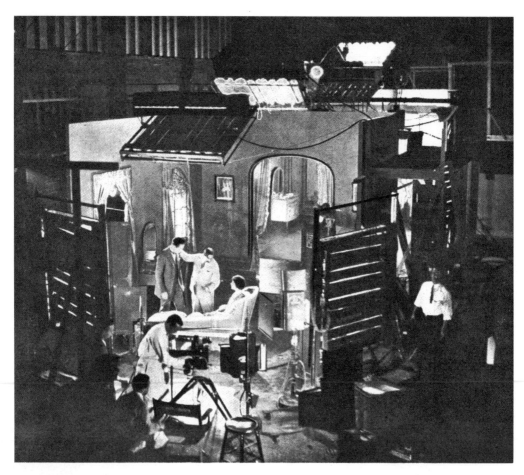

Film-making apparatus

Photo: **PARAMOUNT**
From the film: 'Ehe im Kreise'
(Lubitsch)

Gigantic sums are often spent on making a feature film. Compared with the technique and instrumentation of this film, present-day painterly technique is still at an infinitely primitive stage.

Trick film: a face materialises out of nothing

How it is done: head photographed, film strip warmed, layer of gelatine dissolved and afterwards run through in reverse order.

Photo: **BERLINER ILLUSTRIERTE ZEITUNG**

Photo : **MAGAZIN/DRESDEN**

How animated cartoons are made : the cut-out figures are mounted and the picture shot at half a camera turn, then the limbs of the figures are slightly moved, shot again, etc. until a movement has been completed.

From an animated
cartoon by
Lotte Reiniger

From a sporting
handbook with
cinematographic
illustrations
'Wunder des
Schneeschuhs' by
Arnold Fanck and
Hannes Schneider
published by
Gebrüder Enoch,
Hamburg.

Animated cartoon.
Viking Eggeling: Diagonalsinfonie

Prof. A. Korn: Telegraphed cinema

Prof. A. Korn:
Wireless telegraphed
photography

Photo: **WELTSPIEGEL**

Prof. A. Korn:
Wireless telegraphed
fingerprint

Photo: **WELTSPIEGEL**

L. MOHOLY-NAGY:

DYNAMIC OF THE METROPOLIS

SKETCH FOR A FILM
ALSO TYPOPHOTO

The manuscript sketch Dynamic of the Metropolis was written in the year 1921–22. I hoped to carry it out with my friend Carl Koch, who gave me many ideas for this work. So far, unfortunately, we have not managed to do so; his Film Institute had no money for it. The larger companies like UFA were at that time unwilling to risk enterprises which appeared bizarre; other film-people could 'find no **action** in it despite the good idea' and so declined to film it.

Some years have passed since then and everyone today has some idea of what is meant by the proposition – revolutionary in its effect in the early days – of the FILMIC, that is, of the film which proceeds from the potentialities of the camera and the dynamics of motion. Such films have been shown in 1924 in Vienna by Fernand **Léger** at the **International Festival of Theatre and Music** and in Paris – as an entr'acte in the **Swedish Ballet** – by Francis **Picabia.** Some American comedy films contain similar filmic moments and we may say that by now all good film-directors are concerned to establish the optical effect proper to the film **alone** and that the films of today are constructed to a much greater extent upon tempo of movement and the contrast of light and shade and the various optical views than on theatrical action. This type of film is not concerned with the actor's star-performance, nor indeed with the actor's performance at all.

We are still, however, at the very beginning. Theoretical deliberations, a few experiments by painters and writers which have been based upon their intuitions, chance good fortune during studio work: that is all. What we need, however, is an experimental film centre that will work systematically, with the most intensive promotion by public authorities. Yesterday a few painters were still experimenting on their own. This work was received with suspicion, for the technique of film-production, the whole paraphernalia no longer admits of private effort. The 'best' ideas are useless if they cannot be transposed into practice and thus form the basis of further development. The setting up of a central **film experimental centre** to execute scripts which contain new ideas, even under private, capitalist auspices, will therefore soon be an obvious and recognised necessity.

The intention of the film 'Dynamic of the Metropolis' is not to teach, nor to moralise, nor to tell a story; its effect is meant to be visual, **purely** visual. The elements of the visual have not in this film an absolute logical connection with one another; their photographic, visual relationships, nevertheless, make them knit together into a vital association of events in space and time and bring the viewer actively into the dynamic of the city.

No work (of art) can be explained by the sequence of its elements. The totality of the sequence, the sure interaction of the smallest parts upon one another and upon the whole are the imponderables of the effect. Thus I can explain only some of the elements of this film, so that at least people will not stumble over cinematically obvious happenings.

Aim of the film: to take advantage of the camera, to give it its own optical action, optical arrangement of tempo – instead of literary, theatrical action: dynamic of the optical. Much movement, some heightened to the point of brutality.

Individual parts which do not 'logically' belong together are combined either optically, e.g., by interpenetration or by placing the individual images in horizontal or vertical strips (so as to make them similar to one another), by a diaphragm (e.g., by shutting off one image with an iris-diaphragm and bringing on the next from a similar iris-diaphragm) or by making otherwise different objects move in unison, or by associative connections.

As I was reading the corrections for the second edition, I heard reports of two new films which seek to realise the same aspirations as those proposed in this chapter and the one on Simultaneous Cinema (p. 41). Ruttmann's film 'Symphony of the Metropolis' shows the rhythm of the movement of a town and dispenses with normal 'action'. – In his film 'Napoleon' Abel Glance uses three film-strips running simultaneously side by side.

123

L. MOHOLY-NAGY:
DYNAMIC OF THE METROPOLIS

**SKETCH OF A MANU-
SCRIPT FOR A FILM**
Written in the year 1921/22

A metal construc-
tion in the making

First, animated cartoon of moving dots, lines, which, seen as a whole, change into the building of a zeppelin (photograph from life).

Crane in motion
during the
building of a
house
Photographs:
 from below
 from above

oblique

Hoisting bricks
Crane again: in
circular motion

lose-up.
he movement continues with a car dashing towards the left. A
ouse, always the same one, is seen opposite the car in the centre of
he picture (the house is continually being brought back to the
entre from the right; this produces a stiff jerky motion). Another
ar appears. This one travels simultaneously in the opposite direc-
on, towards the right.

This passage as a brutal intro-
duction to the breathless race,
the hubbub of the city.

The rhythm, which is strong
now, gradually slackens during
the course of the film.

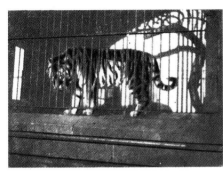

tiger paces furiously round and
ound its cage

'EMPO TEMPO TEMPO

Row of houses on
one side of the
street, translucent,
races right towards
the first house. Row
of houses runs off
right and reappears
from right to left.
Rows of houses
facing one another,
translucent, rushing
in opposite direc-
tions, and the cars
moving ever more
swiftly, soon giving
rise to FLICKERING

TEMPO
TEMPO
TEMPO
TEMPO

The tiger:
Contrast between the open
unimpeded rushing and the
oppression, constriction. So as
to accustom the public from
the outset to surprises and lack
of logic.

uite clear — up at the top — signals:

Close-up.)

ll automatic, au-to-ma-tic in move-
ent

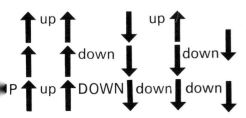

1	2	3	4	5
1	2	3	4	5
1	2	3	4	5

Shunting yard
Sidings

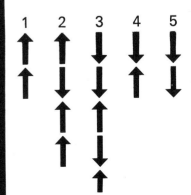

Warehouses and cellars

Darkness

DARKNESS

Becoming gradually lighter

Railway.
Highway (with vehicles).
Bridges. Viaduct. Water below, boats in waves. Cable railway above.
Shot of a train taken from a bridge: from above; from below. (**The belly of the train,** as it passes; taken from a trench between the rails)
A watchman salutes. Glassy eyes.
Close-up: an eye.

he appurtenances of
vilisation heightened by
aking countless levels
tersect and interpene-
ate.
he train from below:
omething never experien-
d before.

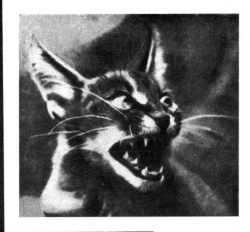

TEM PO

The wheels. They
turn to the point
when the vibration
fades.

PO-O-PO-O-O

Glass lift in a ware-
house with a negro
attendant.
Oblique.
Perspective distor-
ted.
Chiaroscuro.
View out. Tumult.
The dogs tethered
at the entrance. Next
to the glass lift a
glass telephone box
with a man telepho-
ning.

View THROUGH.
Shot of the ground-
floor through the
glass panes.

TEM
TEM
TEM

up down up

The face of the man
telephoning (close
up) — smeared with
phosphorescent
material to avoid pro-
ducing a silhouette
—turns VERY CLOSE
to the camera; above
his head to the
right (translucent)
the aeroplane is seen
approaching in a
spiral from far off.

TEMPO-O
TEMPO-O

1 4 3

3 5 0

ssociation for laborious
lephoning. Dream-like
glass-glass-glass); a grad-
al turn simultaneously
repares the viewer for
he movement of the ap-
roaching aeroplane.

Low aerial photograph
over a square with

8

streets opening into it.

TEMPO -o-

The vehicles : electric trams, cars, lorries, bicycles, cabs, bus,
cyklonette, motor-cycles travel in quick time from the
central point outwards, then all at once they change
direction ; they meet at the centre. The centre opens, they
ALL sink deep, deep, deep —

a wireless mast

(The cam-
era is swif-
tly tilted
over ; there
is a sense
of plung-
ing down-
wards.)

Under-
ground
railway.
Cables.
Canals.

TEMPO

TEMPO-o-o

Under the tramways
the sewers being
extended.
Light reflected in the
water.

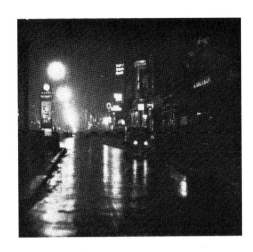

ARC-LAMP, sparks playing. Street
smooth as a mirror.
Pools of light. From above and

oblique

with cars whisking past.

Reflector of a car enlarged.

SCREEN BLACK FOR 5 SECONDS

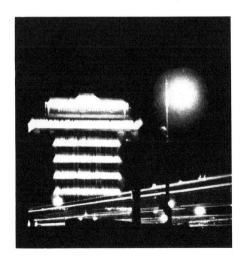

Electric signs with luminous writ-
ing which vanishes and reappears.

Fireworks from the Lunapark.
Speeding along WITH the scenic
railway.

A man can remain oblivious of many things in life. Sometimes because his organs do not work quickly enough, sometimes because moments of danger, etc., demand too much of him. Almost everyone on the switchback shuts his eyes when it comes to the great descent. But not the film camera. As a rule we cannot regard small babies, for example, or wild beasts completely objectively because while we are observing them we have to take into account a number of other things. It is different in the film. A new range of vision too.

Devil's wheel. Very fast.
The people who have been slung down stand up unsteadily and climb into a train. A police car (translucent) races after it.
In the station hall the camera is first turned in a **horizontal,** then in a **vertical** circle.

Telegraph wires on the roofs.
Aerials.
The TIGER.
Large factory.
A wheel rotating.
A performer rotates (translucent).
Salto mortale.
High jump. High jump with pole.
Jumper falls. Ten times one after the other.

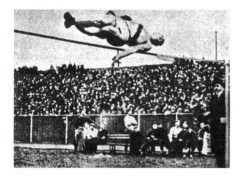

Punch and Judy show.

CHILDREN

Our head cannot do this.

Public, like waves in the sea.

Girls.
Legs.

RIETé,
verish activity.
omen wrestling.
tsch.

zz-band instruments
Close-up).

Football match.
Rough.
Vigorous TEMPO.

Metal cones —
empty inside,
glittering — are
hurled towards the
lens, (meanwhile)
2 women draw back
their heads in a flash.
Close-up.

n order to scare the public. A
ynamic moment too.)

A glass of water (expanse of water with glass rim in close-up) in motion like a fountain, spurts up
Jazz-BAND with the
TALKING FILM
FortiSSimO
Wild dancing caricature. Street-girls.

THE TIGER

BOXING

Close-up.
ONLY
the HAnds with the boxing gloves.

Slow-motion. SLOW-MOTION.

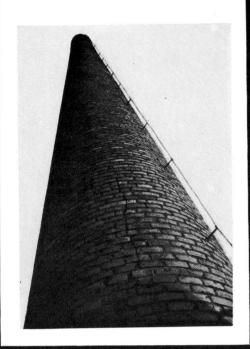

Slanting chimney smokes; a DIVER emerges from it; sinks head first into the water.

THE DIVER

Smoke puffing like a cauli-flower, photo-graphed over a bridge when a train is passing underneath.

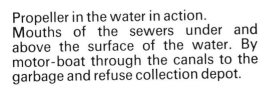

Propeller in the water in action. Mouths of the sewers under and above the surface of the water. By motor-boat through the canals to the garbage and refuse collection depot.

Scrap is converted into factory work.
Mountains of rusty screws, tins, shoes etc.
PATERNOSTER lift with view to the end and back.
In the circle.

From here the whole film (shortened) is run BACKWARDS as far as the JaZZ-BAND (this backwards too).

from **FORTISSIMO-o-o-O**

to **PIA**NISSIMO

Glass of water
Identification of corpses (morgue) from above.

Military parade

RIGHT-RIGHT
RIGHT-RIGHT

MARCH-MARCH-
MARCH-MARCH-RIGHT

WOMEN RIDERS—LEFT
The two shots printed one above the other, translucent.

LEFT-LEFT-LEFT

Stockyards. Animals.
Oxen roaring.
The machines of the refrigerating room.
Lions.
Sausage-machine. Thousands of sausages.
Head of a lion showing its teeth (Close-up).
Theatre. Rigging-loft.
The lion's head. **TEMPO-o-O**
Police with rubber truncheons in the Potsda-
mer Platz.
The TRUNCHEON (close-up).
The theatre audience.
The lion's head gets bigger and bigger until at
last the vast jaws fill the screen.

The frequent and unexpected appearance of
the lion's head is meant to cause uneasiness
and oppression (again and again and again).
The theatre audience is cheerful – and STILL
THE HEAD comes! etc.

Dark for several seconds

DARK DARKNESS

Large circle

TEMPO-o-o

Circus from above, almost a ground-plan.

Lions. Acrobat on skis.
Clowns.
CIRCUS

CLOWN

Dressage

CIRCUS
Trapeze. Girls.
Legs.
Clowns.

LIONS.
LIONS!

CLOWNS.

DRESSAGE

Dressage.

Waterfall thunders. The TALKING FILM.
A cadaver swims in the water, very slowly.

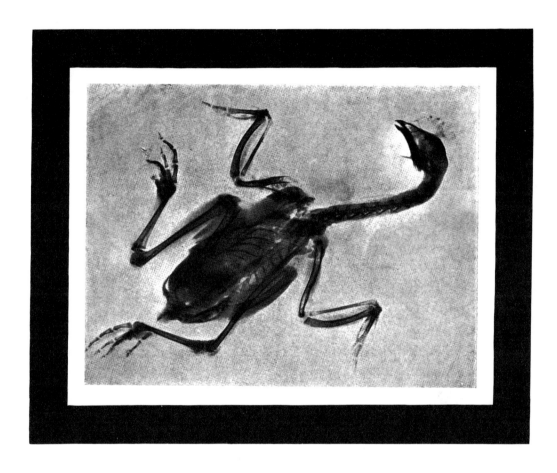

Military. March-march.

Glass of water.

In motion.

SHORT-FAST

Spurts up –

ILLUSTRATIONS:

The photographs reproduced in the **TYPOPHOTO 'DYNAMIC OF THE METROPOLIS'** (page 124-137) are from the following sources:

ILL.	PAGE		
75	124		Building a zeppelin (Photo: FRANKFURTER ILLUSTRIERTE ZEITUNG)
76	124	bottom	Detail from a photograph
77	125		Tiger (Amateur snapshot)
78	125		Railway signals (Photoplastic: MOHOLY-NAGY)
79	126		Warehouse (Photo: K. HAUPT, HALLE)
80	127		A young lynx (Photo: ZEITBILDER)
81	128	top	Aerial photograph of New York (Photo: ATLANTIC)
82	128	bottom	Wireless mast at Nauen (Photo: ATLANTIC)
83	129	top	Berlin, Friedrichstrasse (Photo: AGFA FOTOBLÄTTER)
84	129	bottom	New York (Photo: LÖNBERG-HOLM)
85	130	top	Punch and Judy show (Photo: HAMBURGER ILLUSTRIERTE ZEITUNG)
86	130	left	High jump (Photo: ATLANTIC)
87	130	bottom	Tiller Girls (Photo: E. SCHNEIDER)
88	131	top	Olandia Isatschenko (Photo: TIMES)
89	131	middle	Football match (Photo: RIEBICKE)
90	131	bottom	From the film 'Tatjana' (Photo: UFA)
91	132		The boxer (Photoplastic: MOHOLY-NAGY)
92	133	top	Chimney (Photo: RENGER-PATZSCH)
93	133	right	Burning oil-well
94	133	bottom	Diver (Photo: DIE KORALLE)
95	134		From 'Fridericus Rex' (UFA FILM)
96	135		Lion (DETAIL)
97	136	left	Dressage (Photo: ATLANTIC)
98	136	middle	"Wunder des Schneeschuhs' (Photo: A. FANCK, VERLAG GEBR. ENOCH)
99	136	right	Trapeze artiste Leonardi Renner (Photo: PERLITZ)
100	137		Chicken (X-ray photo: AGFA)

EDITOR'S NOTE

As he observes in the first edition, Moholy-Nagy gathered the material for his book in the summer of 1924. Delayed by technical difficulties, it came out in 1925 under the title 'Malerei, Photographie, Film' as the eighth volume of the 'Bauhausbücher'. The second edition, on which the present one is based, appeared in 1927. Moholy-Nagy made changes from the first edition, mainly in the text, which he extended; the typographical lay-out was tightened, a few illustrations were changed and the title was now spelled in more modern style 'Malerei, Fotografie, Film'. The revision of the text increased the number of pages by six, but a folded supplement reproducing an excerpt from the score of Alexander László's 'Preludes for Piano and Coloured Lights' was omitted from the second edition.

In 1929 Moholy-Nagy brought out another volume in the Bauhaus series; this was called 'Von Material zu Architektur' and was later translated into English; in 1947, shortly after the author's death, George Wittenborn in New York was able to bring out the fourth revised and enlarged edition of this book, which was now called 'The New Vision and Abstract of an Artist'. This work, the origins of which dated from the Bauhaus period, formed the basis of his principal theoretical work, 'Vision in Motion', which Sibyl Moholy-Nagy published posthumously – also in 1947 – with Paul Theobald in Chicago. Moholy-Nagy is continually concerned with light, space and kinetics. 'Painting, Photography, Film', the first of his more important theoretical works, treats this complex of creative questions from a more specialised point of view than do the later ones; but this very specialisation gives the early 'Bauhaus Book' a lasting value even beside the generous proportions of the posthumous 'Vision in Motion', the book which contains the sum of Moholy-Nagy's artistic insights.

H. M. WINGLER

POSTSCRIPT

OTTO STELZER
MOHOLY-NAGY AND HIS VISION

Laszlo Moholy-Nagy saw photography not only as a means of repro-
ducing reality and relieving the painter of this function. He recognised
its power of *discovering* reality. 'The nature which speaks to the cam-
mera is a different nature from the one which speaks to the eye', wrote
Walter Benjamin years after Moholy had developed the experimental
conditions for Benjamin's theory. The other nature discovered by the
camera influenced what Moholy, after he had emigrated, was to call
'the New Vision'. It alters our insight into the real world. Much has
happened in the meantime in this field and on a broader basis than
Moholy could have foreseen. 'Painting, Photography, Film' today exists
as a new entity even in areas to which Moholy's own creative desire
could scarcely have led: for example, in the Neo-Realism of Bacon,
Rivers, Warhol, Vostell and many others whose reality is no more than
a second actuality produced by photography.
Moholy is one of those artists whose reputation continues to grow
steadily after their death because their works have a prophetic action.
Moholy always saw himself as a Constructivist, but he passed quickly
through the static Constructivism of his own time. In a few moves he
opened a game which is being won today. His light-modulators, his
'composition in moving coloured light', his leaf-paintings of the forties,
represent the beginnings of a 'kinetic art' — even the term is his — which
is flourishing today. Op Art? Moholy did the essential spade-work of
this school (the old expression is in order here) in 1942, even including
the objective, important for Op artists, of a 'use': with his pupils in
Chicago he had evolved studies for military camouflage. The display of
these things, later mounted in the 'School of Design' by his collabora-
tor and fellow Hungarian Gyorgy Kepes, was at once the first Op
exhibition, 'Trompe l'oeil', and its theoretical constituent. New mater-
ials? Moholy had been using celluloid, aluminium, plexiglass and
gallalith as early as the Bauhaus days. Modern typography? Moholy has

145

influenced two generations of typographers. Even in the field of aesthetic theory Moholy found a new approach; its aim was a theory of information in art. Moholy enlisted pioneers of this now much discussed theory as long as twenty-five years ago, nominating Charles Morris, the authority on semantics, to a professorship at the New Bauhaus, Chicago and inviting Hayakawa, another semanticist, to speak at his institute. In 1925, when the Bauhaus book now being re-issued first appeared, Moholy was regarded as a Utopian. That Moholy, this youthful radical, with his fanaticism and his boundless energy, radiated terror too, even among his colleagues at the Bauhaus, is understandable. 'Only optics, mechanics and the desire to put the old static painting out of action', wrote Feininger to his wife at the time: 'There is incessant talk of cinema, optics, mechanics, projection and continuous motion and even of mechanically produced optical transparencies, multi-coloured, in the finest colours of the spectrum, which can be stored in the same way as gramophone records' (Moholy's 'Domestic Pinacotheca', p.25). 'Is this the atmosphere in which painters like Klee and some others of us can go on developing? Klee was quite depressed yesterday when talking about Moholy'. Yet Feininger's own transparent picture-space seems not wholly disconnected from Moholy's light-'displays'.

Pascal discovered in human behaviour two attitudes of mind: 'One is the geometric, the other that of finesse'. Gottfried Benn took this up and made the word 'finesse', difficult enough to translate already, even more obscure. 'The separation, therefore, of the scientific from the sublime world . . . the world which can be verified to the point of confirmatory neurosis and the world of isolation which nothing can make certain'. The attitudes which Pascal conceived of as being complementary and connected are now separated. The harmonisation of the two attitudes of mind to which the art of classical periods aspired is abandoned. The conflict between the *Poussinistes* and the followers of Rubens, conducted flexibly from the 17th to the 19th century, became a war of positions with frozen fronts.

The Bauhaus carried on the conflict until the parties retired: on the one side the sublime: Klee, Feininger, Itten, and Kandinsky too, whose 'nearly' Constructivist paintings still reminded Moholy of 'underwater landscapes'; on the other 'geometricians' with Moholy at their head

146

('forms of the simplest geometry as a step towards objectivity'), his pupils and the combatants, Malevich, El Lissitzky, Mondrian, Van Doesburg, all closely connected with the Bauhaus. On the one side the 'lyrical I' (in Benn's sense), on the other the collectivists, 'one in the spirit' with science, social system and architecture, as Moholy formulated it in a Bauhaus lecture in 1923.

The fronts which emerged in the Bauhaus have persisted: things have advanced on parallel lines. Contrasts between phenomena existing simultaneously are among the stylistic symptoms of the present day. Even during the sway of Abstract Expressionism in the 1950's 'Concrete' painters headed by Bill, Albers, and Vasarely (another Hungarian) held their own. And although today 'hard edge' Constructivism, Op Art and technoid art have won much ground, 'painting', hand-writing and the brush-stroke — in short, *belle peinture* and *belle matière* going back in an almost unbroken tradition to Courbet, who, when asked what painting was, held up his hand and replied: 'finesse de doigt' — persist too. Moholy called *belle matière* quite simply 'pigment' and ceased to use it, more radically than Mondrian, who still put on pigment, although not as *peinture*. Moholy rejected (*c.*1925) all hand-produced textures, gave up painting and called for 'drawing with light', 'light in place of pigment'. This beginning led logically to the sequence 'Painting — Photography — Film'.

Moholy was prepared to subordinate the human eye to the 'photo eye' (Franz Roh). A remarkable parallel may be drawn: at the end of the 19th century Konrad Fiedler wrote of the 'mechanical activity of artistic creation', of a 'realm of the visible, in which only the formative activity of the visible, no longer the eye, can advance'. Yet Fiedler belonged to the other side. He meant the mechanical activity of the *hand — finesse de doigt*. The hand takes up the development and continues it 'at the very point at which the eye itself has reached the limit of its activity' — a philosophical basis for 'action painting'. But Fiedler's conclusion is true also of other mechanical activities which create visible things. It is true of photography, in so far as it is handled, as Moholy wished, not traditionally but experimentally. He called for: 'Elimination of perspectival representation', 'Cameras with lenses and systems of mirrors which can take the object from all sides at once', 'Cameras constructed on optical laws different from those of our eyes'. He calls for

'scientifically objective optical principles', the one-ness of art, science, technique, the machine. The astonishing extent of his own technical and scientific knowledge is revealed in the wealth of technological Utopias buried in the footnotes of his Bauhaus book, 'Painting, Photography, Film' — many of these having meanwhile, as befits true Utopias, advanced out of the category of possibility into the category of reality. The artist Moholy's feeling for the camera was in its time radical enough, as Feininger's uneasiness shows. Within photography, however, Moholy moved with surprising tolerance and universality, very differently from our present-day photographers who specialise in either subjective or objective photography, reportage or 'photographics'. Moholy admitted all this, provided that the photographic means were applied in purity in the service of a 'new vision'. His Bauhaus book exhibits with equal pleasure the zeppelin and the Parisian grisette, a head-louse and a racing cyclist, Palucca and a factory chimney, the interior of St Paul's Cathedral in London, seen from above, and a bathing girl in the sand (also from above), the spiral nebula in the Hounds and an X-rayed frog, the camouflage of the zebra in Africa and a pond-fishing experimental station in Bavaria, the eye of a marabou and the 'refined effect of lighting, materials, factures, roundnesses and curves' of a Gloria Swanson from Hollywood. Photographs were taken of the reflections in a convex mirror (the shot on page 103 is not by Muche but by Fritz Schleifer, Hamburg, a former pupil at the Bauhaus). Trick photography is not forgotten, nor photocollage, the favourite of present-day Pop artists — or 'A face emerges out of nothing', embracing phases of the portrait extending from Franz Lenbach to Francis Bacon.

One special photographic effect is, however, much emphasised: camera-less photography, the photogram. Christian Schad and Man Ray had, indeed, conscripted the photogram into the service of artistic experimentation a short time before — but it was Moholy who investigated it not only practically but theoretically, even philosophically. What fascinated him was the mysterious, aperspectival picture-space which could be obtained with the photogram. The cry was now no longer merely 'light instead of pigment' but 'space through light' and *space-time continuum*: 'The photogram enables us to grasp new possibilities of spatial relationships' Moholy was to write later in his book 'Vision in Motion' — for what appears in the photogram is no more than

the effect of the various (measurable) exposures and of the distance of the source of light from the objects, which means that 'the photogram literally *is* the space-time-continuum'.

The Cubists and Futurists too talked much of the fourth dimension, it was the fashion. But Moholy as a pure thinker tried everything, including probing into the scientific side of this system of thought. We can hardly doubt that he knew the work 'Raum und Zeit' by the mathematician Hermann Minkowski – who had become famous in about 1909 – perhaps through his friend El Lissitzky, who was astonishingly well-read and who explicitly mentions Minkowski's world and Riemann's theory of the four-dimensional continuum in the 'Europa Almanach' in 1925. Kepes, Moholy's colleague and successor, enquires at length into Minkowski in his own publications. In 'Vision and Motion' Moholy jokingly compares the 'delicate quality' of the space-time-continuum with a passage in James Joyce's 'Ulysses': 'A very short space of time through a very short time of space'.

Besides light, space, time, that special quality of the play of light with objects – the factor of *colour* – was, of course, infinitely important to Moholy throughout his life. The photogram could not give him colour and so his longing for colour soon led him back to painting. But in his last years he was working on colour photography and he wrote: 'The greatest promise for the future will lie in mastering the colour photogram'.

Once we establish the fact that Moholy's later discoveries are anticipated and pin-pointed in the Bauhaus book 'Painting, Photography, Film', the importance of this incunable becomes clear. Should the work still appear strange to present-day readers, the only possible advice is that they should immerse themselves in the story of Moholy's later life. Sibyl Moholy-Nagy has told it in an affecting and at the same time exemplarily objective manner (Moholy-Nagy, 'Experiment in Totality', New York 1950). We are moved to learn how Moholy, the great artistic educator, educated himself. The man who in his youth complained that Malevich used the word 'emotion' wrote shortly before his death: 'It is the duty of the artist of today to penetrate the still unrecognised defects of our biological function, to investigate the new fields of the industrial society and *to translate* the new discoveries into *the stream of our emotions*'. He said to his wife Sibyl: 'A few years ago I could not

have written that. I saw in emotionalism nothing but a carefully cultivated frontier between the individual and the group. Today I know better. Perhaps because I was a teacher for so long, I now see in emotionalism the great linking bond, rays of warmth which are reflected, answer and sustain us'. As Mondrian in his last paintings abandoned the straight-edge and restored to the free stroke of the hand its right to speak, so a few days before his death Moholy with a free and eager hand engraved lines and signs in the finest of his plexiglass sculptures — thus creating a link between the spheres of noology and biology.